WILD THINGS

THE HIDDEN WORLD OF ANIMALS

Michael Runtz

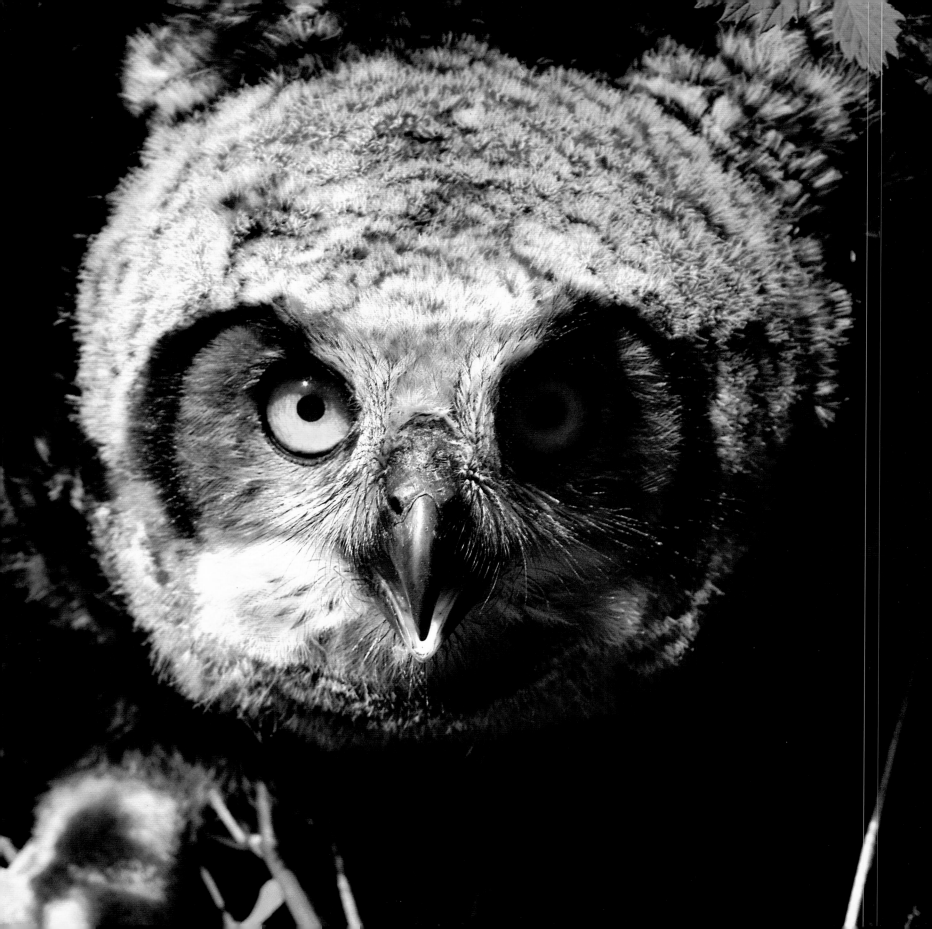

WILD THINGS

THE HIDDEN WORLD OF ANIMALS

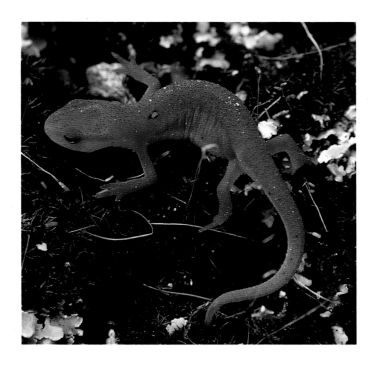

Michael Runtz

A BOSTON MILLS BOOK

Canadian Cataloguing in Publication Data

Runtz, Michael
 Wild Things: the hidden world of animals

Includes bibliographical references and index.
ISBN 1-55046-140-0

1. Animals. 2. Animals - Pictorial works.
I. Title

QL45.2.R8S 1995 591 C95-930871-7

Cover: Red Fox
Page 2: young Great Horned Owl
Page 3: Red Eft
Page 6: Cecropia caterpillar
Back cover: Bullfrog

The publisher gratefully acknowledges the support of the Canada Council, Ontario Arts Council and Ontario Publishing Centre in the development of writing and publishing in Canada.

First published in 1995 by
The Boston Mills Press
132 Main Street
Erin, Ontario
N0B 1T0
(519) 833-2407 fax (519) 833-2195

An affiliate of
Stoddart Publishing Co. Limited
34 Lesmill Road
North York, Ontario
M3B 2T6

Stoddart Books are available for bulk purchase for sales promotions, premiums, fundraising, and seminars. For details, contact:
 Special Sales Department
 Stoddart Publishing Co. Limited
 34 Lesmill Road
 Toronto, Canada M3B 2T6
 Tel. 1-416-445-3333
 Fax. 1-416-445-5967

Design by Andrew Smith

Copy-editing by Heather Lang-Runtz

Page composition by Andrew Smith Graphics Inc.

Printed in Korea

To Harrison and Dylan:
May the natural world fuel your imaginations
and enrich your lives as it has mine;
in return may you give back to it
something of equal importance.

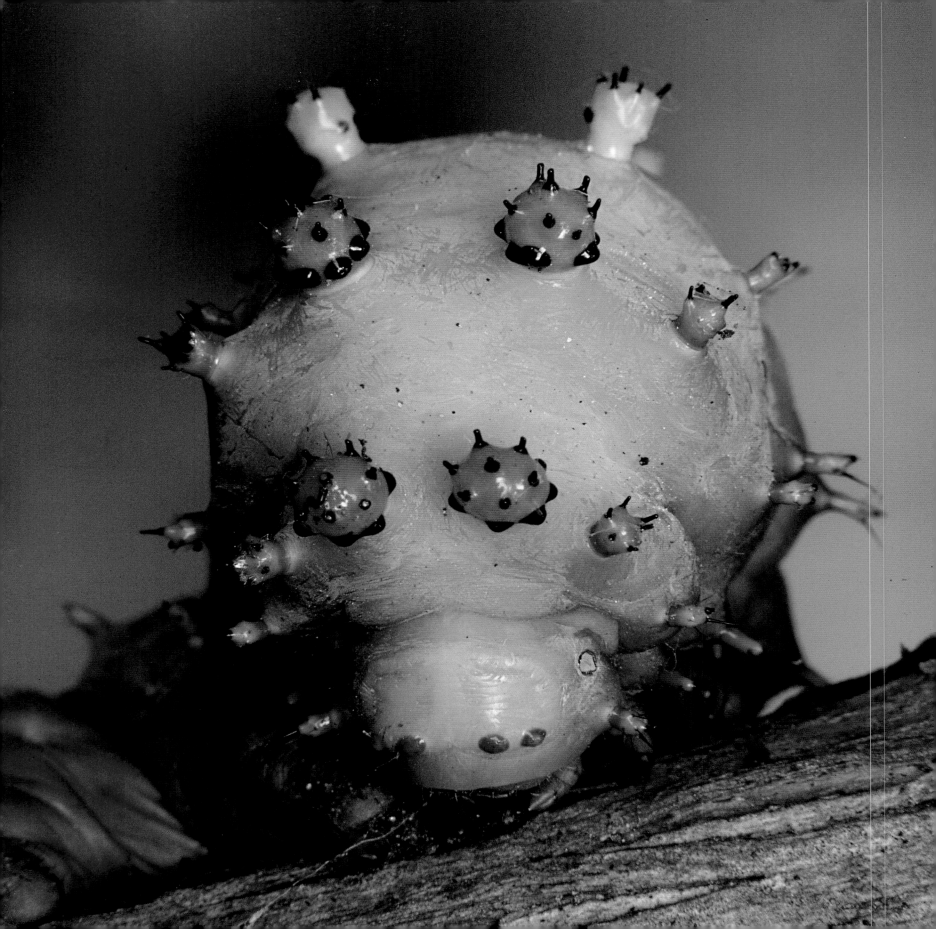

CONTENTS

ACKNOWLEDGMENTS

OVER THE YEARS (THEY ALWAYS PASS FAR TOO QUICKLY!), countless comrades have imparted to me invaluable knowledge and inspiration. To the many friends whose names do not appear below, I remain forever grateful.

To the following, my sincere thanks for your assistance during the formation of this book: Howard Bole, Bob Bracken, Peter Burke, Peter Carson, Dr. Francis Cook, Stephen Darbyshire, John and Denise Drew, Doug Elliot, Patti Freier, Mary Gartshore, Donnie and Nora Gordon, Tom Hince, Dr. Fiona Hunter, Lisa McLaughlin, Brian Penney, Patrick Perdichuk, Kent Prior, Alison Stuart, Don (Sandy) Sutherland, Adolf Vogg, Dr. Patrick Weatherhead, Don Wilkes, World Wildlife Fund/Jeremy Inglis, and Ryan Zimmerling.

A special thanks also to A. Ron Waters of Kodak Canada, Inc. for providing the Kodak film used in this project, and to Fumitaka Yamada and Leo Robichaud of Canon Canada Inc. for Canon's continuing support.

Last but never least, heartfelt appreciation to my wife, Heather, for always supporting my activities, whether they constitute being out in the field with a camera or stuck in front of a computer screen muttering unpleasantries!

INTRODUCTION

EVER SINCE OUR SPECIES FIRST APPEARED ON EARTH, wild animals have played important roles in our lives. Many are important foods; some are fierce competitors; a few are even feared adversaries.

These relationships have very much governed the way we have traditionally looked at wild animals. But when we look beyond their interactions with us and explore their natural world, a spellbinding story unfolds. Complex relationships with their environment and fascinating interactions both between and within species abound. In the realm of wild animals, elegant adaptations and elaborate behaviors are the rule, not the exception.

Our fascination with wild things has often been reserved for larger animals, particularly birds and mammals. Perhaps their visibility can account for this. Or perhaps we presume that these are "higher" animals, and they therefore exhibit more advanced and complex lifestyles than the "lower" forms, such as spiders, snails, and insects.

Nothing could be farther from the truth. All animals, from a 10-ton Right Whale to a one-tenth-of-an-inch-long (2 mm) Black Fly larva, display marvelous modifications crucial to their survival. Regardless of their size or the habitat in which they live, every species must overcome environmental adversity, defend themselves against predators, find adequate food, and, most importantly, reproduce. In the natural world, where basic life problems are a given and must be surmounted, all species are truly equal. There are no "lessers" and no "greaters." Any perception of there being a hierarchy in the animal kingdom is simply a product of human vanity.

While every species must overcome all of these basic challenges, it is never the case that there is only one applicable solution to any given obstacle. This is what I find most intriguing about the animal world. Every animal occupies a relatively specific niche, and so each is presented with its own unique set of environmental constraints, which include non-living

(abiotic) factors, such as temperature, wind, and precipitation, and living (biotic) factors, such as other organisms. Combined, these constraints create ecological pressures exclusive to the animal. And so what is a successful strategy for one organism may prove disastrous for another. Out of the need to resolve any single problem facing an animal, a remarkable diversity of solutions has arisen.

Through time, these ubiquitous ecological forces mold or fine-tune any feature that offers an advantage to an animal's survival and, ultimately, to its reproductive success. Any characteristic that proves to be maladaptive is soon weeded out. This uncompromising selective pressure, known as natural selection, was recognized by Charles Darwin as the driving force behind evolution. Along with sexual selection, a subset of selective pressures associated only with reproduction, natural selection is responsible for the incredible wealth of appearances and behaviors that exists in the animal kingdom today.

But the natural world, with its slowly evolving transformations and ongoing refinements, is a transitory one. The animals we see today live under the continuous scrutiny of natural selection. They have undergone tremendous changes in the past, and those species that survive may well undergo dramatic changes to their appearance and behavior over the millennia to come. And so, when we admire a wild animal, we must remind ourselves that we are only glimpsing a brief moment—a snapshot—in that species' existence.

We should celebrate the beauty and dynamic complexity of all wild things. But we should also accept that each organism is unique and therefore irreplaceable. Without this appreciation and concern for each and every living thing, we risk not only losing any number of these precious marvels but also the very core of life that supports our own kind.

VANISHING ACTS & ARTFUL GUISES

ONE IRREFUTABLE TRUTH IN NATURE IS THAT EVERY animal is food for something else. No matter where an animal roams, danger is ever present: it lurks on potentially every leaf, in every tree, through every forest. Death soars the skies and stalks the still waters. At no time does complete sanctuary exist, for a gauntlet of hungry mouths must be avoided both in the dark of night and the light of day. As well, hazards increase as animal size decreases, with smaller animals having to contend with greater numbers and types of predators.

This unrelenting pressure has resulted in the evolution of a marvelous array of animal defenses, some simple, others so spectacular that we struggle to explain their origins. Comparative complexity aside, however, each type of defense confers some survival advantage on its holder.

A most basic form of defense works on the principle "out of sight, out of mind." Actually, "out of sight, out of mouth" might be a more appropriate rendition. When not actively feeding, many animals avoid hungry adver-

Camouflage is common in insects, and caterpillars are masters of the art of blending into the background.

saries by blending into the background. We effectively use camouflage in the form of mottled coverings or actual pieces of the local environment to hide equipment or ourselves from prying eyes. But nature holds the copyright on this very effective defense system, with wild animals the true masters of unparalleled vanishing acts. Countless species from numerous classes (insects, birds, amphibians, and mammals, for example) use camouflage as part of their defense arsenal. For an animal to remain undetected, however, camouflage alone is not enough. Cryptic coloration (concealment) must be coupled with cryptic behavior if this strategy is to work.

Many animals that spend a lot of time on the ground sport a blotched, earth-toned pattern, which often strongly resembles dead leaves. Brown, gray, and black feathers dominate the upperparts of ground-nesting birds, such as Ruffed Grouse and Whip-poor-wills, as well as many shorebirds, including American Woodcocks. Combined, this coloration and a motionless posture enable the animal to escape detection by even the most discriminating eyes.

Ground-nesting birds, such as this Short-eared Owl, usually combine earth-toned camouflage with cryptic behavior.

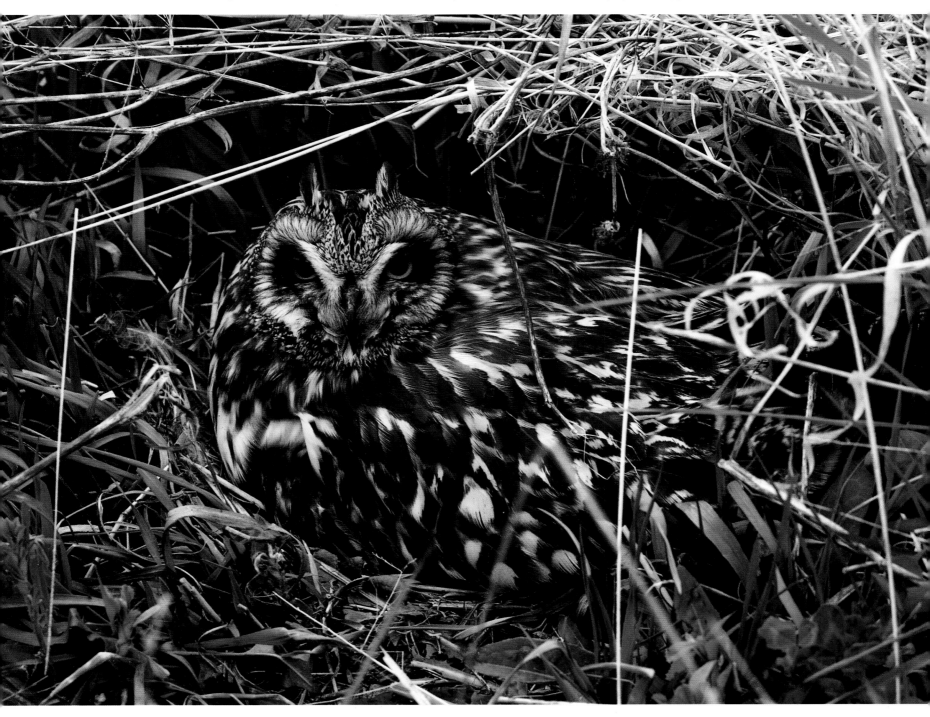

VANISHING ACTS & ARTFUL GUISES

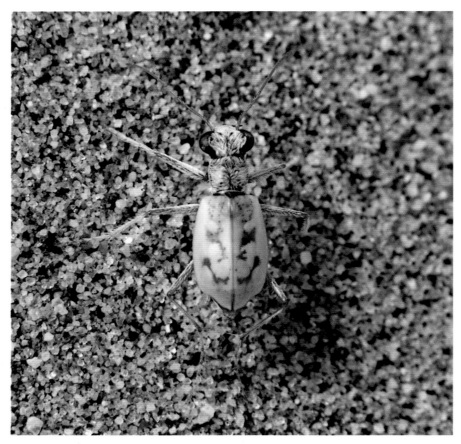

(Above) Many insects that inhabit sandy regions are quite pale, such as this White Tiger Beetle.
A few animals, including this Gray Tree Frog (right), can adjust their body color to match the color of their background.

Camouflage can also closely match the physical appearance of tree bark or twigs. Many types of caterpillars feed at night, when temperatures are cooler and most birds that prey on insects are sleeping. During the day, the caterpillars cling motionless to twigs, leaves, branches, or bark and are often inseparable in appearance from the object on which they rest. Inchworm caterpillars will even hold their rigid bodies out from a branch, furthering the illusion of being a twig. Other tree-inhabiting animals bear patterns resembling mossy or lichen-covered bark, and a few, such as the Gray Tree Frog, possess the amazing ability to adapt their color to match their background.

Not all camouflage consists solely of blotches. The bodies of animals that live in an environment dominated by the vertical lines of grasses or reeds are often adorned with streaks or stripes. When alarmed, American Bitterns point their beaks to the sky and freeze, confident that their striped breasts will make them vanish into the cattails. Savannah Sparrows and other field-dwelling birds are able to disappear quickly into the tall grasses because of streaks on both their backs and breasts. And, unless it moves, the striped Garter Snake is next to impossible to pick out among the foliage growing along a pond's edge.

Some body markings are designed to make the animal blend into the nearby vegetation; others serve to disrupt

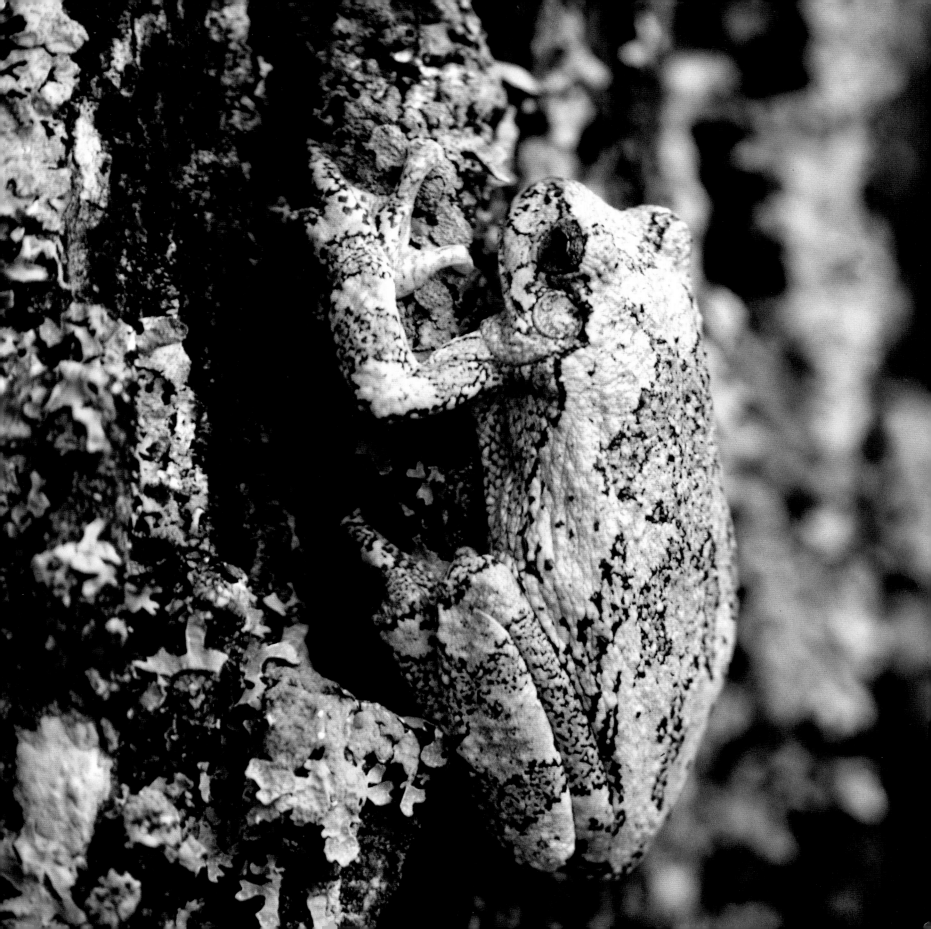

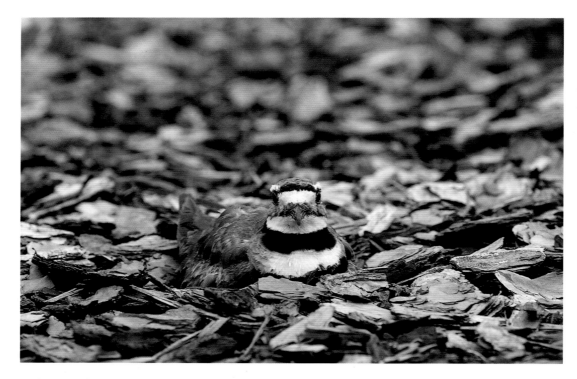

The breast bands of a Killdeer disrupt the bird's outline, making it more difficult for a predator to spot.

the animal's outline. It is no easy task for a fox or any other earth-bound hunter to spot nesting Horned Larks, Semipalmated Plovers, or Killdeers, whose breast bands break up their shapes, making them difficult to detect from ground level. The profusion of spots on baby White-tailed Deer renders them virtually invisible when they are laying down on the forest floor. Disruptive patterns are also a common feature on birds that make cup-shaped nests and incubate with their heads projecting over the nest's rim. Many songbirds, including Chipping Sparrows, Red-eyed Vireos, and Blue-gray Gnatcatchers, bear eye stripes, spectacles, or eye rings that serve to break up the shape of the exposed head.

However, camouflage is more than just discrete color

patterns. A variety of aquatic insects lacks any other pattern save black above and white below. But for Water Boatmen and other water-inhabiting insects that face predatory attacks from both below and above the water's surface, this bicoloration offers tremendous survival advantages. Fish and other aquatic predators have trouble discerning the insect's white underside against the brightness of the sky. When viewed from above, the dark upper surface blends in well with the waterway's murky bottom. Many aquatic insects follow this principle, with one notable exception. In a reversal of the logical configuration, Backswimmers display a dark underside and a light upper surface. But as their name suggests, Backswimmers propel themselves through the water with their bellies

When a nesting Common Loon lowers its head to the waterline, its neck band and the profusion of spots on its back serve as disruptive patterns.

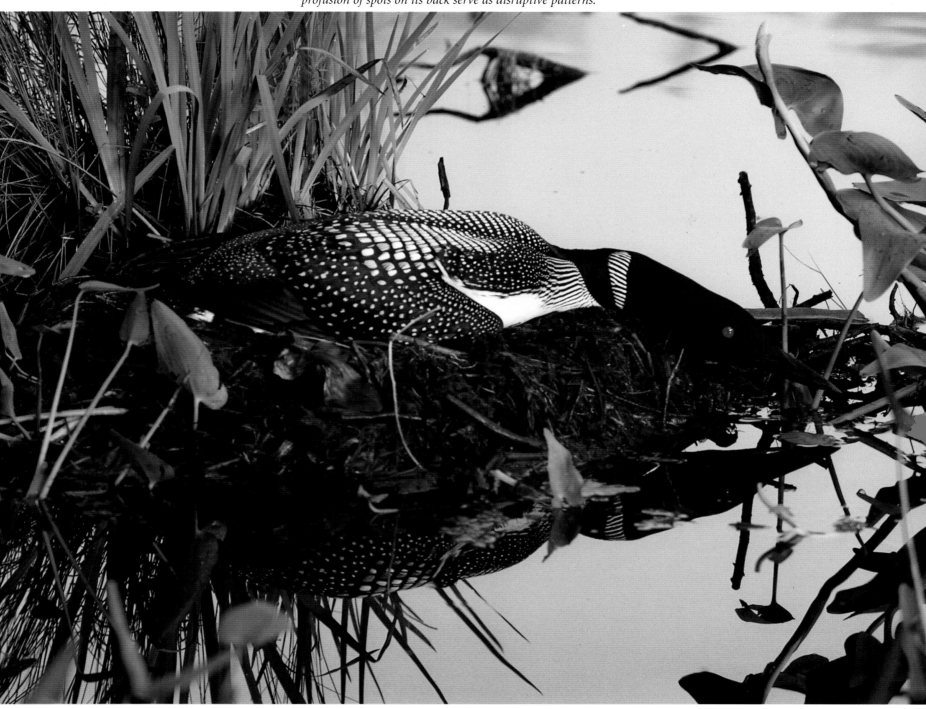

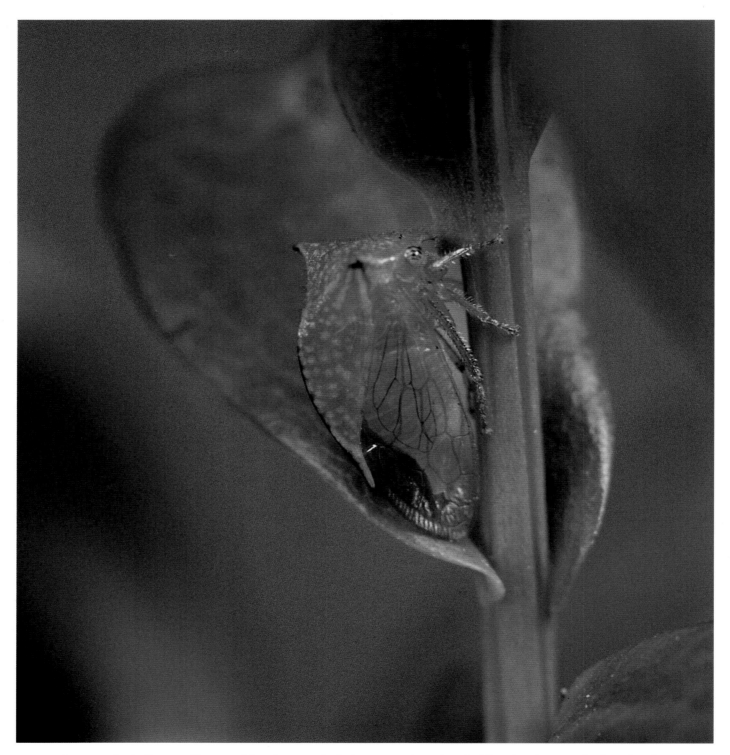

Treehoppers physically resemble part of the plant on which they are resting. Their leaflike wing venation furthers this illusion.

facing up. So, while the actual color placement differs, the underlying premise of bicoloration remains the same for both the Backswimmer and those insects that swim in a more traditional manner!

A number of terrestrial mammals also display this bicoloration feature. But White-tailed Deer do not face danger from above and below; rather, their attackers normally view them from ground level. So how could a dark upper torso and a pale underside protect them? Obviously their bicoloration does not function in the same way as for an aquatic insect.

Light falling on a standing animal—a deer, for example—causes its belly to be shaded by its upper body. If a deer were uniformly brown, the belly would actually appear darker than the upper parts because of the shadow. This contrast would create a three-dimensional effect, causing the animal to stand out more strongly from its background. But because the belly is lighter than the upperparts, the shading lessens the contrast, giving the deer a more uniform or "flatter" appearance. A "flat" deer is more difficult to pick out from the background, particularly at a distance. Known as countershading, this effect may be why the bodies of many land animals are two-toned.

Physical resemblance to a specific part of the environment is also an important camouflage feature in the animal world. Treehoppers have thoracic projections that give them the appearance of thorns or buds, Question Marks and other angle-winged butterflies mirror dead leaves when they close their wings, and Walking Sticks

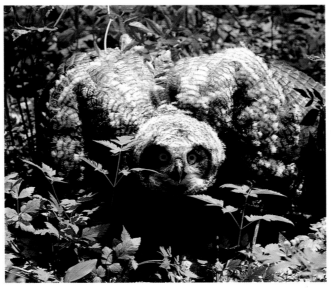

By spreading its wings and puffing up its feathers, a young Great Horned Owl tries to intimidate an attacker.

look remarkably like twigs. On the other hand, some animals resemble objects that are relatively conspicuous and actually contrast with the immediate scenery. The caterpillars of Viceroy, Red-spotted Purple, White Admiral, and Giant Swallowtail butterflies look nothing like the leaves on which they rest—for good reason. Few predators are willing to sample bird droppings on the off chance that one might happen to be one of these edible caterpillars (which bear a most convincing resemblance to such waste products). Even a few moths, such as Wood-nymphs and Bird-dropping Moths, employ this somewhat "crappy" defense.

Some animals rely on their physical markings for camouflage, while others exploit their surroundings. Casebearer Moth caterpillars live in silken cases adorned with pieces of vegetation and their own excrement. Caddisfly larvae live on the bottom of wetlands, with each species inhabiting a different waterway. Most species build a casing out of nearby materials and use it as a camouflaged mobile home. Caddisflies that live in lakes with sand bottoms, for example, build elegant cases solely out of sand grains. Other species that live in shallow ponds cement together pieces of plant debris. If you have ever gazed into a beaver pond and have seen a piece of the bottom move suddenly, you were probably witnessing a Caddisfly larva with its home in tow.

Another type of defensive housing resembles residues left by large animals clearing their throats. Bubbly masses of froth commonly situated on low-growing plants are home to the nymphs of Froghoppers. Known as

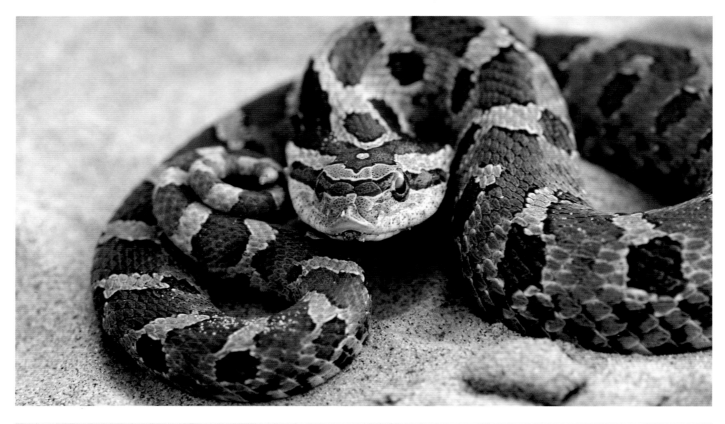

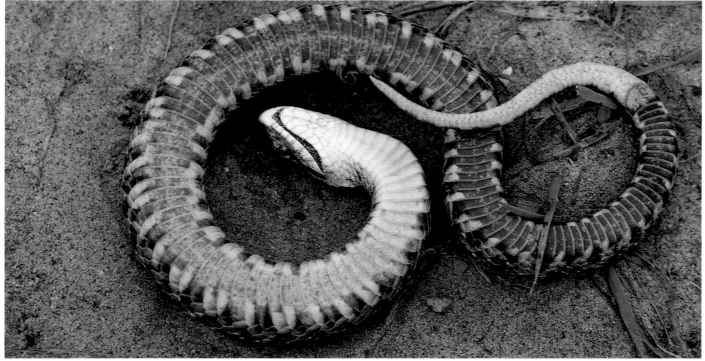

Spittlebugs, these small insects feed on the sap of plants. Excess water from the sap is released out the anus as droplets and covers a nymph. As the Spittlebug grows larger, it whips the liquid into a bubbly froth with a breathing tube cum air jet and gyratory abdominal movements. The resulting spitlike mass not only helps to hide a tender nymph from its predators but also protects it from parasites and disease.

Disguise and deceit are commonplace in the animal world. While in most instances these defenses help an ani-mal avoid a predator, at other times the deception can take the form of direct confrontation, even intimidation. By inflating themselves with air, American Toads look quite formidable and possibly too large for the attacker to handle. Young Great Horned Owls just out of the nest can be even more intimidating. When confronted by danger, they quickly transform from cute, cuddly balls of down into possessed demons. They hunch out their wings, fluff up their feathers, hiss hideously, and noisily click their beaks.

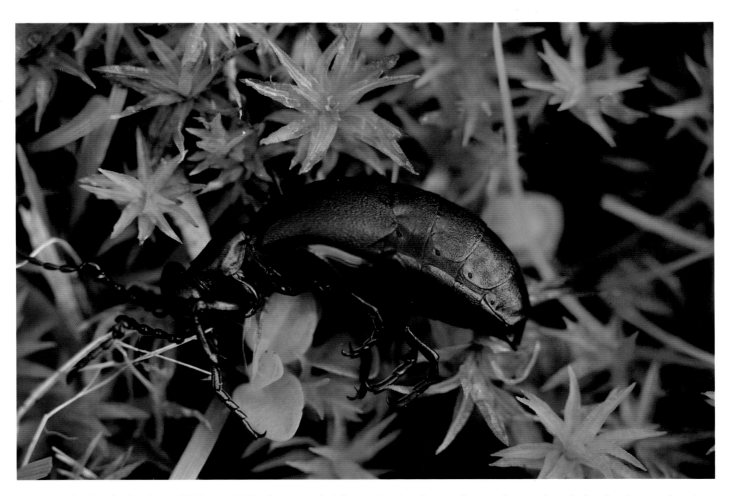

Playing dead is the first line of defense of this Blister Beetle (above). But just in case the attacker persists, the beetle releases a burning chemical from its leg joints. (Opposite) If a Hog-nosed Snake's intimidation act fails to discourage its adversary, it employs phase two of its defense arsenal. By suddenly rolling over and playing dead, this amazing snake tries to make the predator lose interest.

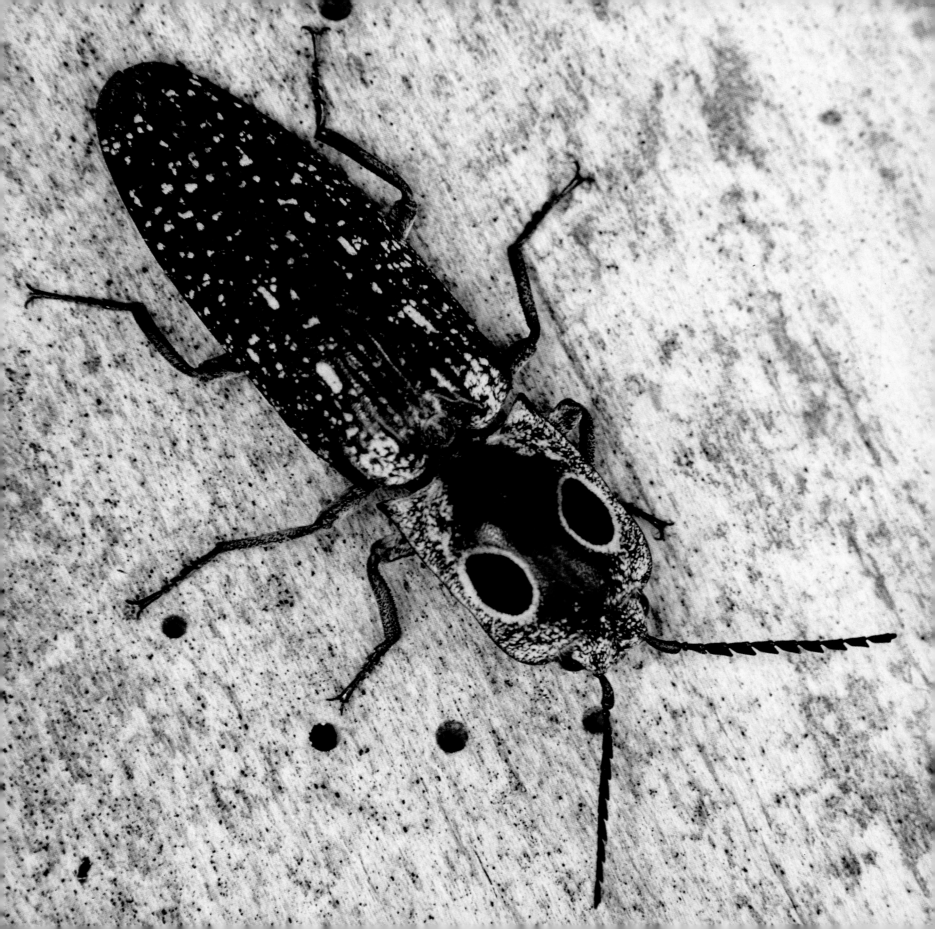

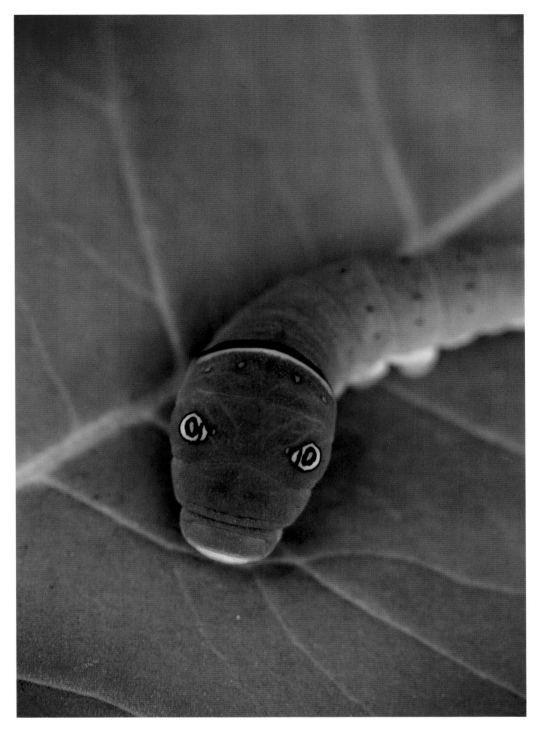

(Opposite) Huge false eyes make Eyed Elaters look larger and more intimidating. (Above) Tiger Swallowtail caterpillars also possess this "eye-opening" defense.

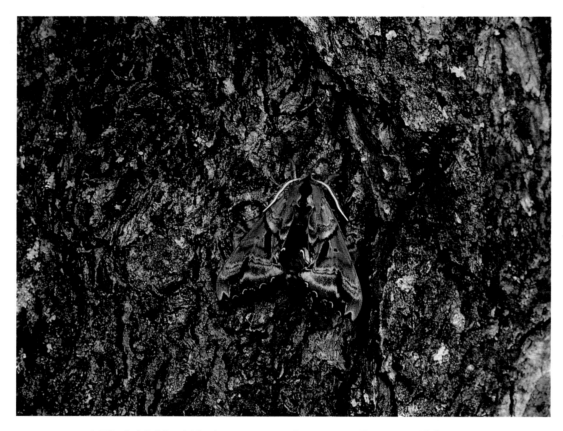

A Blinded Sphinx hides its eye-spots and uses camouflage to avoid detection.

A frightening act of intimidation is also presented by the harmless Hog-nosed Snake. When alarmed, it puffs up its upper neck, hisses loudly, and strikes out boldly. If this bluff fails to make its antagonist back off, the snake suddenly collapses and rolls over onto its back, an apparent victim of heart failure. Its mouth, often full of sand, falls open and in a few cases its tongue flops lifelessly out. Blood oozes out of the mouths of some individuals, furthering the illusion of death. Convincing death acts are also used as a defense by Virginia Opossums and a few species of Blister Beetles. Playing dead (thanatosis) may prove to be a viable defense, particularly for those animals that tend to be killed but not eaten by larger animals. Once the attacker is convinced that the perceived danger has been eliminated, it may leave the "carcass" untouched (and patiently waiting for a safe reincarnation). For Blister Beetles, though, the predator that continues its attack is in for an unpleasant taste-test. During its death act, the beetle releases foul-tasting cantharidin-containing droplets from its leg joints.

Much smaller animals also employ intimidation as a

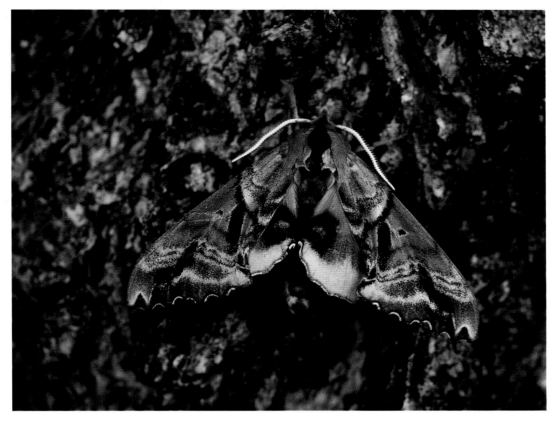

When disturbed the moth unveils its bold patterns, startling the predator as it makes good its getaway.

strategy. Caterpillars are considered juicy morsels by a number of birds. However, some species undergo a startling transformation, giving a predator serious second thoughts about grabbing the potential meal. The caterpillars of Pandorus Sphinx and Tiger Swallowtails have massive false-eye spots. These illusionary eyes magically change the caterpillar into a potentially dangerous snake or some other formidable creature—definitely not the tasty meal the predator had in mind. Other insects, including the Eyed Click Beetle (also called the Eye Elater), bear large false eyes in their adult stages.

Not all eye-spots are permanently on display. Io, Polyphemus, and many Sphinx Moths rely first on their cryptic coloration to hide them. But if the moth is detected and must flee, when its wings are opened a pair of massive eyes suddenly glares out at the attacker. The startled predator pulls back in shock, thereby allowing the moth to make good its escape.

Underwings and other moths, as well as Band-winged Grasshoppers, lack eye-spots but have bright patterns on their hindwings. As with other startle patterns, these are hidden when the animal is resting and revealed when

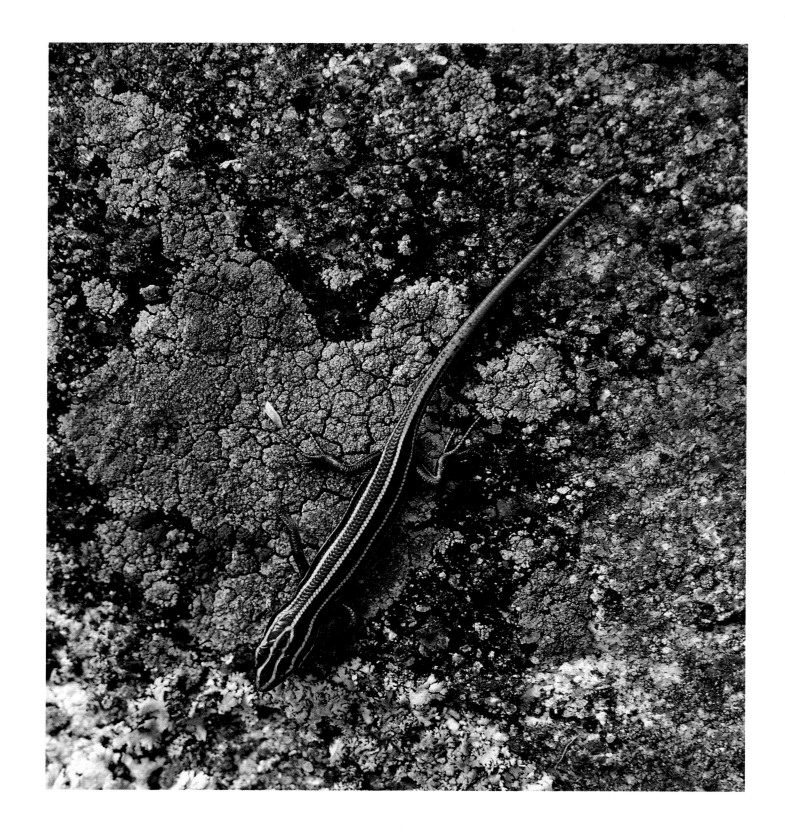

(Opposite) The brilliantly colored tail of a juvenile Five-lined Skink deflects a predator's attack to this easily detached and expendable body part.

under attack. By shocking an attacker, they provide valuable seconds for the insect to flee.

Startle patterns also serve a second life-saving function. If a predator recovers in time to make a grab for the insect, it often centers its attack on these markings. But as the patterns are situated on the hindwings, which are not critical for flying, the insect usually escapes even after being bitten. Because these designs deflect a predator's attack to a non-vital body part, they are also known as distraction patterns.

Many butterflies also have distraction patterns in the form of false eyes or, in the case of the Swallowtails, Hairstreaks, and other "tailed" butterflies, false antennae on the hindwings. But effective as a startle or distraction pattern may be initially, over time its protective value can wane as predators become used to it. However, habituation is uncommon because several species with different patterns usually inhabit the same area. A mixture of patterns appearing unpredictably lessens the chances of a predator developing a search image for any single one. Good examples of this are the Underwing Moths or Sphinx Moths: rarely do less than half a dozen species of either group occur in any region.

One of the most dramatic examples of distraction patterns is found in Five-lined Skinks. The young skinks' brilliant blue tails direct a predator's attack to this part of the body. When grabbed, the tail immediately breaks free from the body and begins to thrash wildly. The tail-less lizard then makes good its getaway, the predator's attention being thus occupied with its lively prize. A new tail will grow back, but undoubtedly at considerable physiological cost to the skink (although still a significantly better alternative than death!). Red-backed Salamanders also exhibit self-induced tail-loss (caudal autotomy) and the amazing ability to regenerate this body part.

To contend with the real and constant risk of becoming food for something else, many wild animals have developed ingenious guises and employ remarkable vanishing acts. For other animal species, however, illusions have no place in their bag of tricks; a good offense has proven to be the best defense.

TRUTH OR DARE

Not all wild animals escape from perceived danger by cryptically hiding. Some come so well equipped with body armor or other physical protection that they are rendered quite unpalatable or inaccessible, and need not mask their presence. Armadillos are virtual living tanks, being covered in bony plates overlaid by horn. By pulling in their limbs and sitting tight against the ground, they protect their soft belly, the only vulnerable part of their body. Calcified shells protect the soft bodies of snails, clams, and other molluscs. Once the animal has withdrawn inside and sealed off the entrance, its impenetrable fortress may also prevent a predator from detecting the occupant by smell.

But perhaps the ultimate body armor is sported by turtles. The fact that the general configuration of these reptiles has changed little over 200 million years is testimony to the effectiveness of their defense! The bony shell consists of an upper portion (the carapace), joined by bony ridges and ligaments to a lower section (the plastron). Once a turtle pulls its legs, head, and tail into the shell, it is safe from almost every kind of predator.

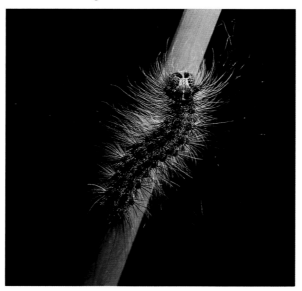

The copious hairs of Gypsy Moth caterpillars deter most birds from eating them.

Most turtle species are able to retract all their extremities, but Blanding's Turtles can also partly close the opening because of a weakly hinged plastron. Box Turtles are able to close their shell completely, due to a more developed hinge. But not all turtles are afforded full protection by their shells. The poorly developed plastron of Snapping Turtles makes it impossible for this species to withdraw inside its shell for protection. When caught out of water, their only means of defense consists of snapping at the attacker with their powerful jaws—a tactic that has earned these slow-moving reptiles an undeserved reputation of being dangerous.

For some animals, including many caterpillars, body protection comes in the form of modified hairs. Tiger, Tussock, and Dagger Moth caterpillars are often covered in long hairs that render them indigestible to most birds. A few other caterpillars, such as those of Io Moths and Buck Moths, have branched poison spines that sting wickedly on contact—a strong incentive for insect-eaters to leave these creatures off their menu.

Insects are not alone in their use of protective hairs,

Once withdrawn inside its shell, a Blanding's Turtle faces little danger from predators. The effectiveness of this armor may well be the reason that the basic body plan of turtles has changed little over the past 200 million years.

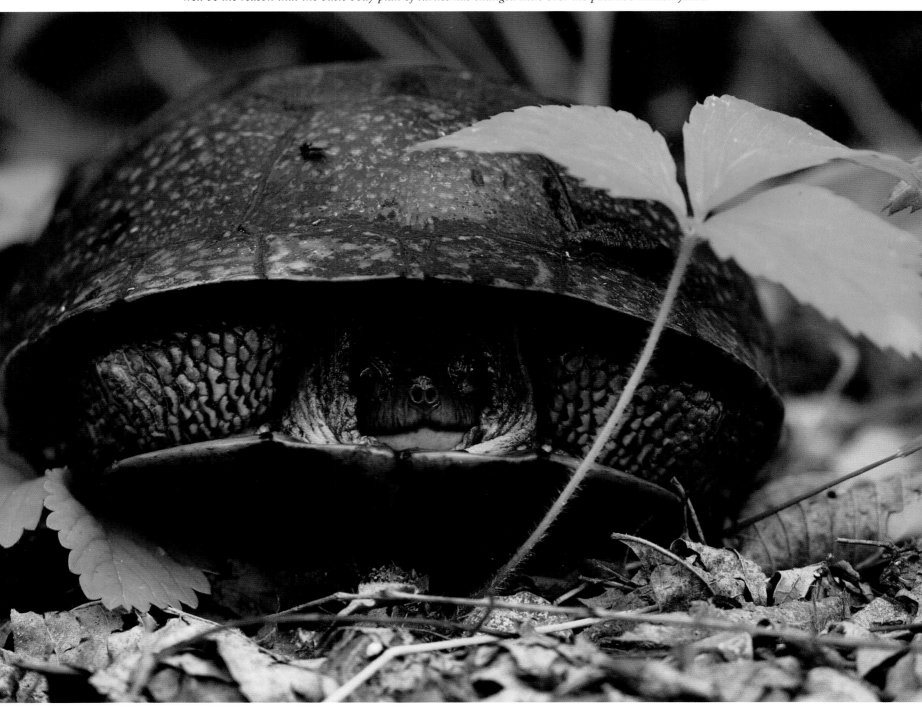

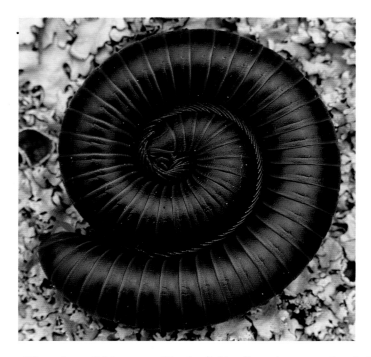 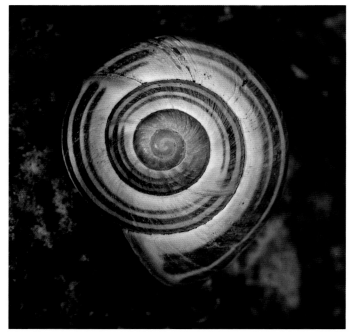

When alarmed, Narceus *millipedes (left) coil up, thus protecting their legs, head, and underside. The fortified shells of snails (above right) may offer more than just physical protection. Once sealed, a shell also prevents a predator from locating the occupant by smell. Porcupines (opposite) have modified hairs that dislodge easily from the bearer, but not the recipient, due to overlapping scales on the tips.*

however. The Porcupine is world-famous for its prickly coat of defensive hairs. Its stiff, thick, yet lightweight quills—modified guard hairs—are equipped with overlapping barbs or scales, which make them difficult to extract from victims, including poor old Fido. When the impaled muscles contract around a quill, the scales also provide the impetus for it to travel through the victim's flesh.

An adult Porcupine is endowed with as many as 30,000 quills on its upper body and tail, with the longest located on the back and neck. When the Porcupine becomes excited, the quills are held upright at all angles, forming an impenetrable network of spears. Shorter quills are found on the tail but, contrary to popular belief, cannot be thrown at attackers. Rather, all quills are loosely attached to the skin and thus are easily dislodged on contact. When it finds itself under attack, a Porcupine gives

plenty of warning before employing its pain-inflicting defense. First, it loudly chatters its teeth. Next, it releases a repugnant chemical, possibly from a skin tract above the tail base. Only when these warnings fail to deter the predator does the physical defense come into play. Keeping its backside toward the adversary's face, the Porcupine repeatedly swings its tail. A facial implant of quills is usually enough to deter even the most persistent predator.

Porcupine quills contain a coating of antibiotics. Although this may be beneficial to a Porcupine that has impaled itself (perhaps by falling out of a tree, as these slow-moving animals are prone to do), the antibiotic coating may actually be designed to benefit the stricken predator. By allowing its attacker to survive with a lifelong memory of the consequences of its foolishness, the Porcupine could, in

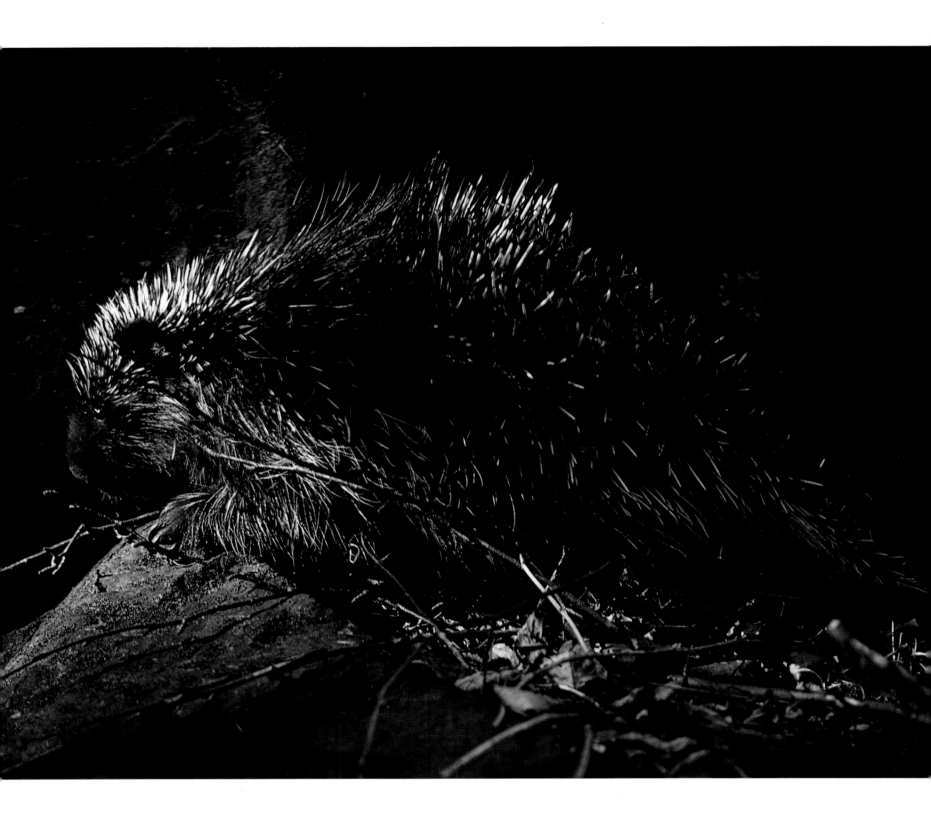

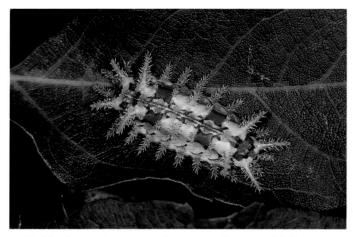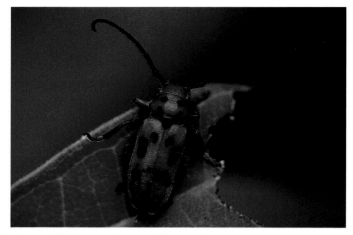

Bold colors and patterns often warn of a powerful defense. (Left) Spiny Oak Slug Moth caterpillars employ stinging spines, while (right) Red Milkweed Beetles contain poisonous chemicals taken from milkweeds.

fact, be enhancing its own survival chances. For if the predator were to die from infections caused by the quills, an inexperienced replacement might arrive on the scene and repeat the error of its predecessor. Once again, the Porcupine and its offspring would be put at risk.

As is the case for other animals possessing a potent defense, a rather obvious visual pattern advertises the Porcupine's presence. White quill shafts on the lower back and along the tail edges provide a sharp contrast to the otherwise black hairs. Viewed from the backside, this pattern is easily discerned, particularly at night, when the animal is most active.

Another highly nocturnal animal, the Striped Skunk, also advertises its unpleasantness with a bold black-and-white pattern. But apart from their sharp teeth, skunks lack any form of physical protection. However, a potent chemical defense is ample compensation. The overpowering sulphur alcohol spray, a virtually foolproof predator repellant, is forcibly released through a special nipple protruding from the anus. But as with all dispensable defenses, a physiological cost is involved in its manufacture and use. Therefore, skunks, like Porcupines, try to conserve energy by employing ample warning signals before using

their weaponry. By stamping their feet, elevating their oversized tails, hissing, and champing their teeth, skunks provide obvious signs of their displeasure.

Chemical defenses are commonplace in the insect world. Many species contain toxins that are present in the plants upon which they feed: Tiger Moths accumulate alkaloids from ragworts; Monarchs store cardiac glycosides from milkweeds; and Pine Sawfly larvae orally discharge oily terpenoids taken from pine needles. Some insects manufacture their own concoctions, with release methods as dynamic as any defense tactic employed by much larger animals. Bombardier Beetles deserve special mention. When alarmed, this beetle raises its abdomen and aims it high into the air, directly at the adversary's face. With the artillery in place, the missile loading proceeds internally. Separate stores of hydroquinone and hydrogen peroxide are released into a collecting bladder. When a valve is opened, the mixture enters a special thick-walled chamber where the chemicals quickly and explosively interact under the influence of an enzyme catalyst. With a startling "pop," the chemical weaponry—a 210 degrees Fahrenheit (100°C) cloud of burning quinone gas—is launched directly into the eyes of the unsuspecting predator.

While Bombardier Beetles and Striped Skunks employ their defenses rather dramatically, the majority of animals possessing chemical weaponry use them in much more subtle ways. Blister Beetles under siege ooze irritating cantharidin out their leg joints. Many salamanders secrete samandrin, a neurotoxin, through their skin. Foul-tasting corrosive poisons called phenols, discharged through the anus of Dytiscid Water-beetles, cause a predator to regurgitate the unpleasant meal quickly.

Regardless of where they are stored or how they are used, chemical defenses are most often owned by rather conspicuous animals. Bold colors and contrasting patterns clearly warn that the bearer is not to be eaten without dire consequences. While nocturnal animals sport black-and-white patterns, diurnal animals generally display red, orange, or yellow markings as warnings of their formidable defenses. Yellow-jacket Wasps can deliver painful stings and advertise this consequence with bright yellow-and-black bodies. The bright orange skin of Red Efts warns of noxious skin secretions. Red Milkweed Beetles are protected by cardiac glycosides, stolen from the milkweeds on which they feed.

Naturally, warning or aposematic coloration works to discourage a predator's interest only if the predator has had a previous bad experience. But often only one vile meal is necessary for an animal to learn that the bold and easily recognized appearance of that fateful meal should be avoided in all future encounters.

Bold and bright—an inedible sight. The principle seems simple enough, but in nature there are always exceptions to any rule. Numerous harmless or edible animals bear the same bold appearances as animals endowed with

Monarchs (left) honestly advertise their unpleasantness with a bold orange-and-black pattern. (Right) Viceroys, which are edible, take advantage of the Monarch's defense tactic by mimicking that butterfly's distinctive appearance.

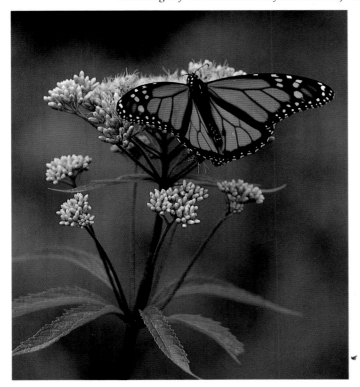 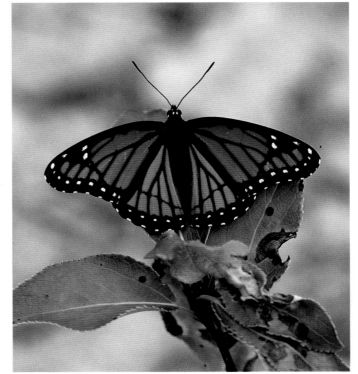

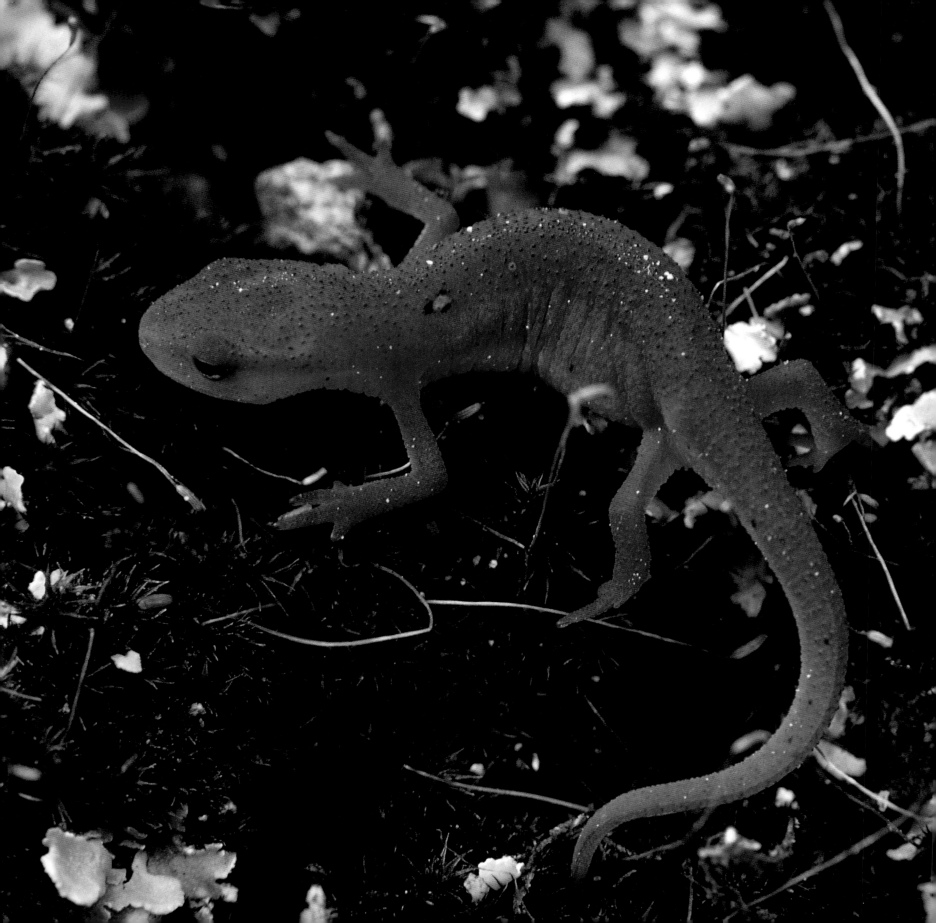

chemical defenses. These "imposters" are, in fact, relying on a predator's awareness that a specific appearance is one to avoid. In this way, they achieve the protection of a valid defense without expending the physiological energy needed to produce it. British entomologist Henry Bates was the first to examine this amazing phenomenon, now known as Batesian mimicry.

Monarch butterflies contain cardiac glycosides, inherited from the caterpillar stage; the caterpillars acquired them from the host plants, the milkweeds. These distinctive orange-and-black butterflies are ignored by birds that have previously experienced the violent retching associated with a Monarch repast. By avoiding butterflies bearing that pattern, however, the birds are also unknowingly passing up quite edible meals. Although most Viceroys lack poisonous defenses, their uncanny resemblance to the Monarch leaves them untouched by Monarch-wise birds.

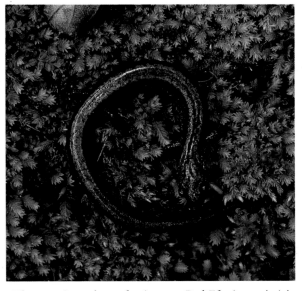

The warning colour of poisonous Red Efts (opposite) is exploited by Red-backed Salamanders (above).

But there is a price to pay for all those animals that exploit Batesian mimicry as a defense. If a predator is to learn quickly that potential prey with a specific appearance is not to be eaten, the harmless mimic must be less prevalent than its unpleasant model. For if the mimic were more common than its model, odds are the predator would initially have a positive eating experience. It would then be more inclined to sample that pattern again. And if the foul-tasting models were rare, a predator would probably tolerate the odd negative experience as long as rewarding experiences dominated.

For obvious reasons, stinging insects are avoided by most animals. It is not surprising, then, that the distinctive patterns found on wasps, hornets, and bees are mimicked by a number of harmless insects. Because of this, a bold yellow-and-black-banded insect might be a Vespid Wasp, Hover Fly, Soldier Fly, Clearwing Moth, Long-horned Beetle, or Flower Beetle. Many Hover Flies are so convincing that often there are only two quick ways for humans to identify if the insect is a wasp or a fly. One way is to count the wings, as wasps have two pairs and flies only one. If counting proves to be impossible, grabbing the insect by hand will soon reveal the truth!

An amazingly large number of harmless insect species exploit the appearance of those that sting. In part, this considerable number is possible because so many stinging insects—bees, wasps, and hornets—resemble each other in their color patterns. This similarity affords a greater degree of protection for the entire stinging group: a bird that samples one type avoids all others. Mullerian mimicry, named after the German zoologist Fritz Muller, is the term used to describe a group of animals that shares some unpleasant attribute and looks remarkably alike.

Although Batesian mimicry is widespread among insects, it is not limited to this group. Red Efts, the terrestrial juvenile stage of Eastern Newts, advertise their toxicity with bright orange skin. Red-backed Salamanders bear a similar color on their dorsal surface. This resemblance spares the salamander attacks from animals that have previously tasted a newt. But not all Red-backed Salamanders have "red" backs. A gray or "lead-back" phase is also found. However, as would be the case if true mimicry were involved, where efts are common, the "red-backed" phase is more often encountered; where efts are rare, this phase is rarely observed. Even

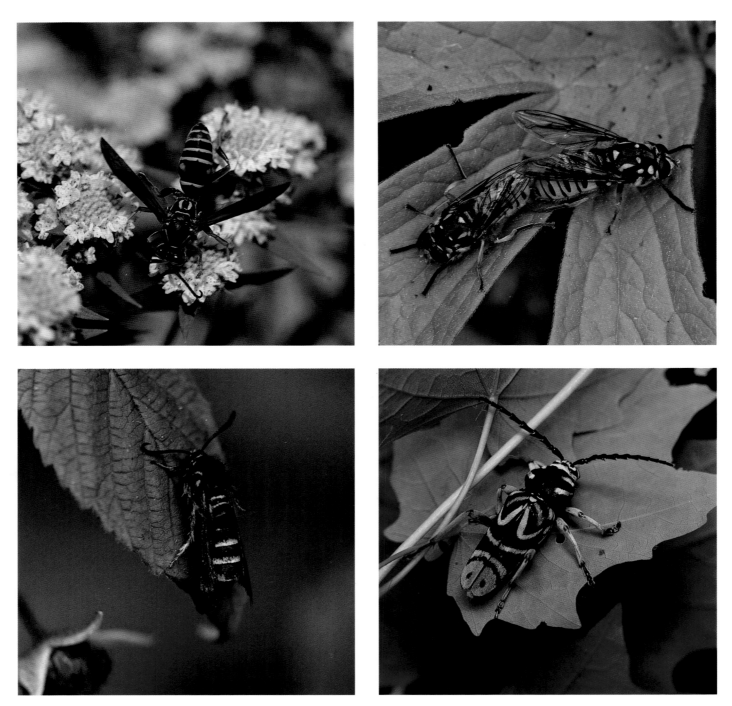

The potent defense of wasps and bees (top left) is the underlying reason that so many harmless animals copy the appearance of these stinging insects. (Top right) Many Hover Flies, (above left) Clearwing Moths (here, a Raspberry Crown Borer), and even a few beetles, such as this Sugar Maple Borer (above right), convincingly resemble one of these formidable creatures.

Red-bellied Snakes may gain a survival advantage from their subtle resemblance to an Eft when they expose their orange underside during a predator's attack.

A few snakes also demonstrate Batesian mimicry. The bright red, black, and yellow bands of poisonous Coral Snakes are most convincingly replicated in Mexican Milk, Scarlet King, and Scarlet Snakes. Not only do harmless snakes physically resemble poisonous snakes, some also mimic their behavior. Rattlesnakes use venom to kill and digest prey, and secondarily as an effective defense. But as with most animals that employ physiologically expensive chemicals, conservation is the rule. Before using this costly defense, rattlesnakes first give ample warning by vibrating the tail rattle, an overlapping series of loose,

horny segments, producing a loud buzzing sound. However, several harmless snakes make a similar noise, effectively warding off potential danger. Milk Snakes and Rat Snakes may lack tail rattles, but they are able to mimic the rattling noise by rapidly vibrating their tails against dry leaves, sticks, or the hard ground.

"Truth" or "dare": this is often the dilemma confronting a predator looking at a potential meal. The natural world is full of convincing bluffs as well as legitimate warnings. Chances are, a predator that has previously sampled poorly will accept the warning as a valid one and forego the feast. Indeed, the old adage "once bitten, twice shy" may well be the underlying principle of many successful animal defenses.

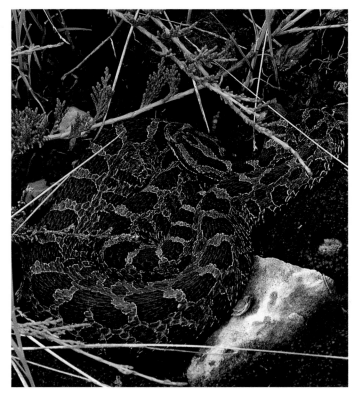
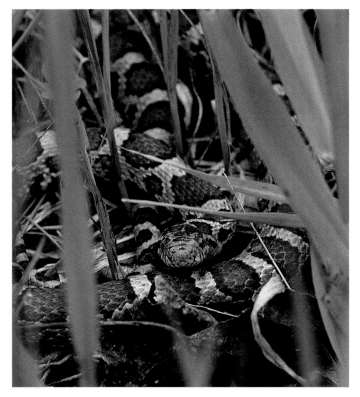

(Left) Mimicry can extend beyond physical appearances. The warning tail buzz of Massasauga and other rattlesnakes is closely imitated by a number of non-venomous snakes, such as this Milk Snake (right).

TOOLS OF THE TRADE

Unlike most plants, animals are unable to manufacture all of the compounds necessary for maintaining life. This limitation has forced them to acquire essential minerals, amino acids, and fatty acids from vegetation. Animals do this in two basic ways: they either consume plants directly or they devour other animals that contain nutrients stolen from plants. Although quite different, both strategies are characterized by a near-infinite variety of modifications and specializations.

The majority of animals obtain essential nutrients directly from plants, either living or dead. Leaves, stems, roots, fruit, seeds, petals, stamens, pistils, sepals, bracts, sap, pollen, and nectar: every part of a plant is used as food by some animal. A few species even eat bark and wood. Indeed, virtually all plants, whether 300-foot-tall (100 m) Redwoods or tiny algal blooms, support a number of different animals. Some animals are specialists and feed only on one type of plant; other animals are less selective and able to utilize a variety of plant species. Both methods have their advantages: specialization offers more efficient use of the food and a leg-up on the competition, while generalization provides flexibility, which could be a lifesaver in times of stress. Whether for feeding or any other life function, no adaptation is without its inherent drawbacks. Specialists suffer when their food plants become rare, while generalists may lose out in competitive interactions with other species.

(Above) The elegant labral brushes of Black Fly larvae filter tiny particulate matter from fast-flowing water. (Opposite)The powerful beaks of Evening Grosbeaks and other finches serve the same function as cheek teeth for dealing with unwieldy seeds and nuts.

Every part of a plant provides feeding opportunities for animals. Sap is stolen by the piercing stylets of Aphids and Plant Bugs. With their peculiar crossed mandibles, Red Crossbills pluck the seeds from between pine cone scales. Bark Beetles chew elaborate galleries in the wood of spruce trees. Black Bears and Cedar Waxwings devour the fruit on cherry bushes.

All animals must perform a balancing act between the amount of time spent foraging and that allotted to the rest of their daily activities. Evasion of predators and parasites, mate attraction, territory defense, and care of the young are all factors that enter into this complex budget. Every animal species must also weigh the caloric returns against the cost of

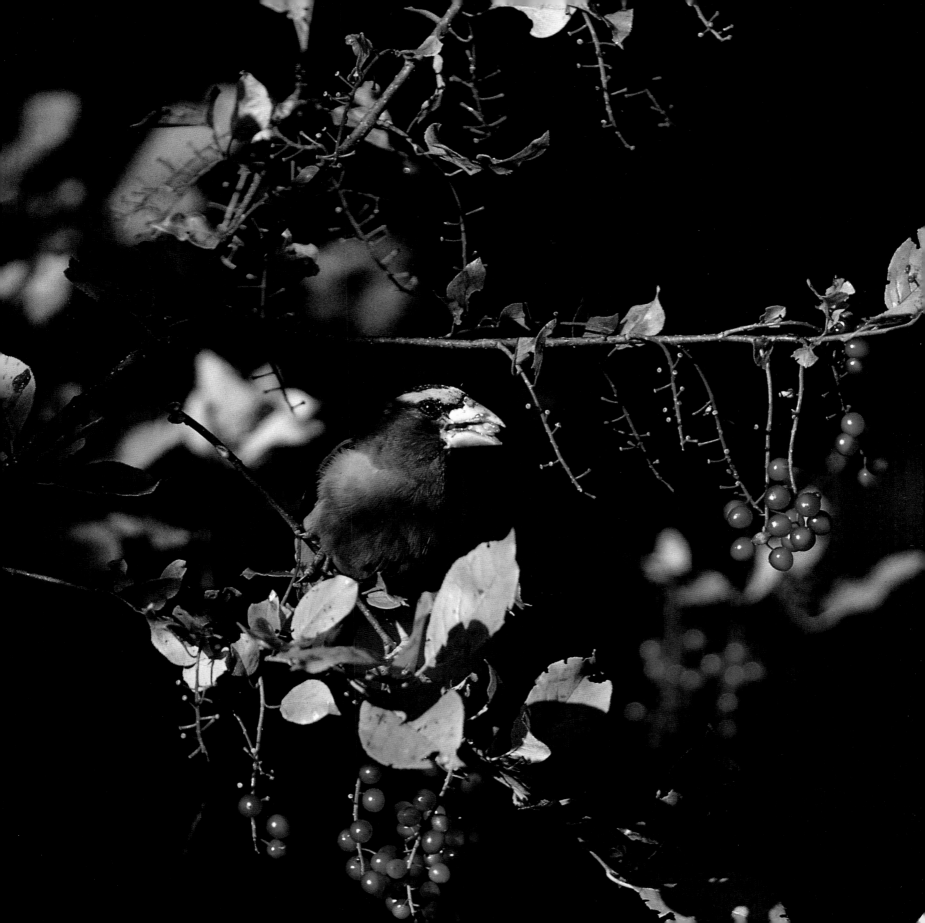

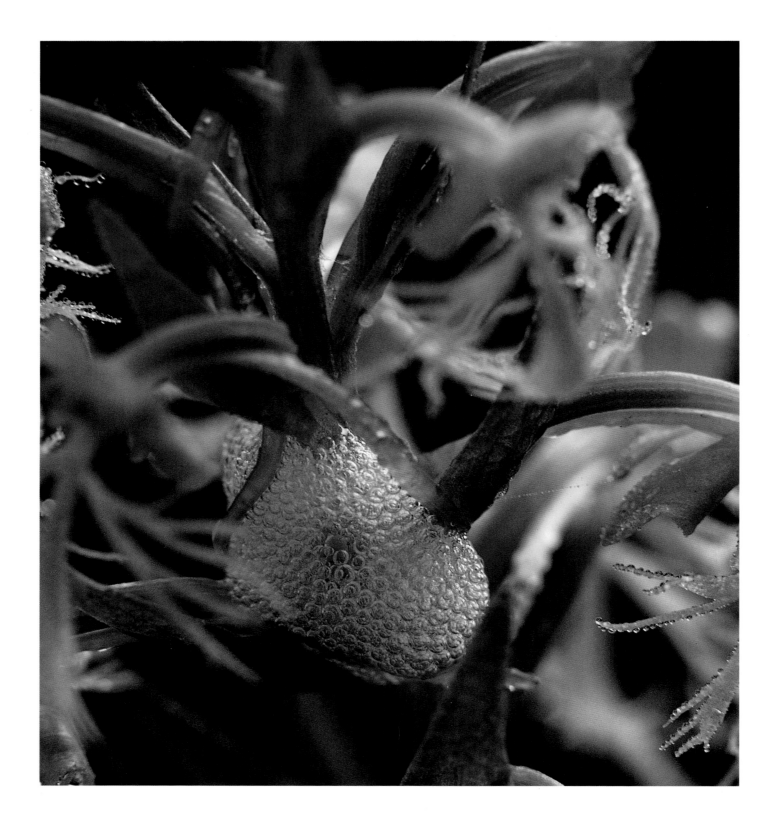

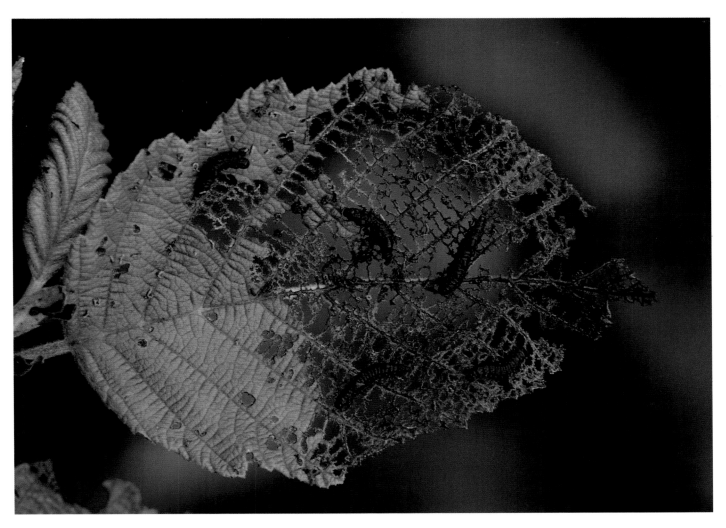

No part of a plant escapes becoming food for animals. Alder Beetle larvae (above)
acquire many of their essential minerals from the leaves of alders. Spittlebugs (opposite) suck sap from the safety of a bubble
chamber formed with excess liquid.

acquiring and consuming a certain food. Moose, for example, get high energy value from the leaves of Trembling Aspen and other deciduous trees, but these plants do not provide sufficient amounts of sodium. On the other hand, Water-shield and other aquatic plants yield a rich supply of that essential element but have little energy value. Moose, then, must balance the time spent foraging on land, building up energy stores, against the time spent in the water, replenishing depleted sodium reserves.

Plant-eaters vary tremendously in size, but the majority are quite small. Many roam through the soil and leaf litter, devouring either algae or detritus, organic litter partly formed from decaying plants. Animals that exploit this food source—soil mites, roundworms, and Springtails—are usually small,

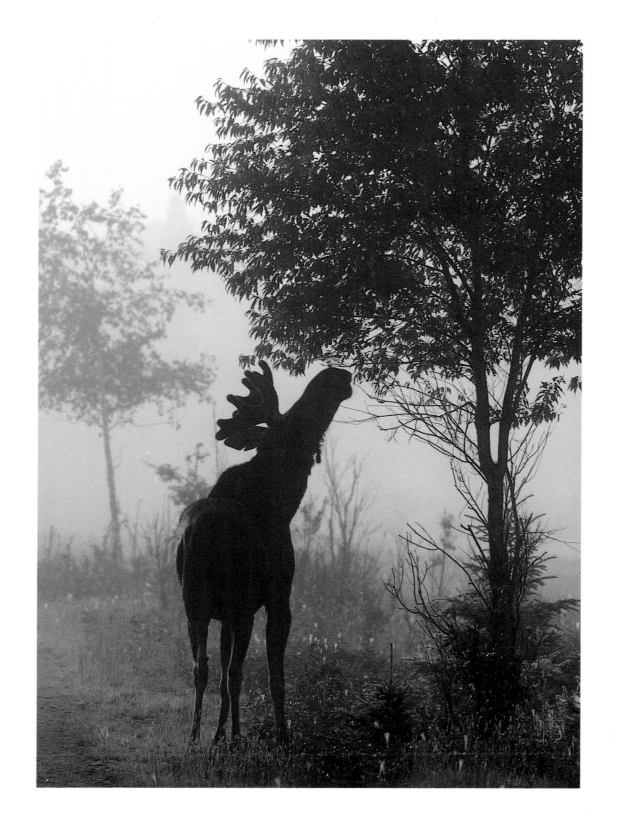

dwarfed by the largest detritivores, such as earthworms and millipedes. Particulate-feeding animals in aquatic environments often have one major advantage over their terrestrial counterparts in that their food often comes with free delivery. Currents carry organic particles to clams, sponges, and moss animals (bryozoans), which filter them out as the water passes either over or through their structures. An astonishing amount of water is strained by these animals in their feeding efforts. In a single year as much as eighty percent of a lake is filtered by the clam fauna inhabiting the bottom!

Insect larvae also exploit the wealth of organic matter floating in a water-filled environment. Net-spinning Caddisflies use trumpet-shaped nets to filter their food from shallow rapids. Black Fly larvae cling to rocks or sticks in rushing streams, sweeping particles from the chilling current with elegant labral brushes. Filter-feeders conserve energy by maintaining a relatively sedentary lifestyle, but an inability to relocate if food resources vanish and inescapable exposure to any pollutants (particularly metals) present in the water are two major disadvantages.

(Opposite) Plants support not only small insects but also gigantic herbivores, such as Moose. Bacteria in the rumen attack the plant matter, which is later regurgitated as a cud for more leisurely mastication. (Below) Cud-chewing often occurs while the animal comfortably reclines.

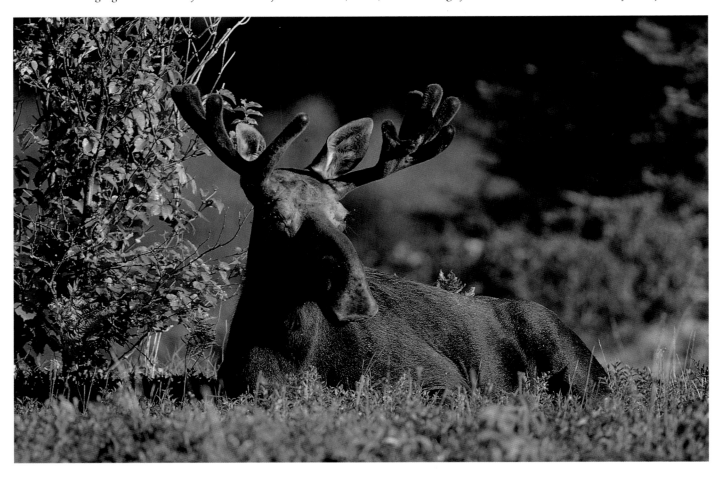

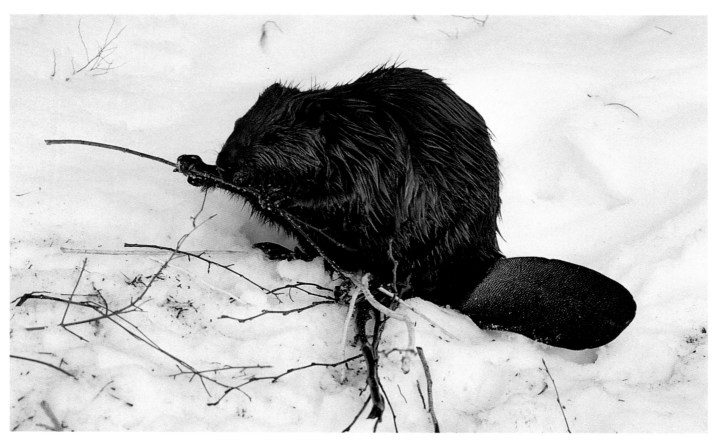

(Above) As with Moose, Beavers process a meal twice to glean unused nutrients. But because their bacterial colonies are positioned so far along the digestive tract, they recycle their food by consuming their feces.
(Opposite) Toadflax Moth caterpillars and most other lepidopteran larvae resolve their inefficiency in digesting plant tissues by devouring several times their weight in foliage every day.

On land, a huge array of animals feast on terrestrial plants. The eating of plant material, at first glance, seems simple enough. But the hairs, spines, and other physical defenses borne by many plants make it difficult for food to be ingested easily. Once swallowed, the material is extremely hard to digest because of the tough cellulose, hemicellulose, and lignin structural components. Many plants also come loaded with nasty toxins. To compensate, plant-eating animals have developed an arsenal of external and internal adaptations for eating plants.

The first challenge for a herbivore is to break off workable pieces of a plant. To serve this purpose, plant-eating animals have developed a variety of tools. While the type of tool varies considerably from animal to animal, many are analogous structures, having the same function but arising from different origins. Snails and slugs possess a radula, a veritable rip saw, on the floor of their mouth. This horny, continuously growing, conveyor-beltlike apparatus is armed with sharp teeth, which rasp material from leaves and stems as the radula is worked against a horny jaw in the top of the mouth. Grasshoppers and caterpillars lack this tool, but their

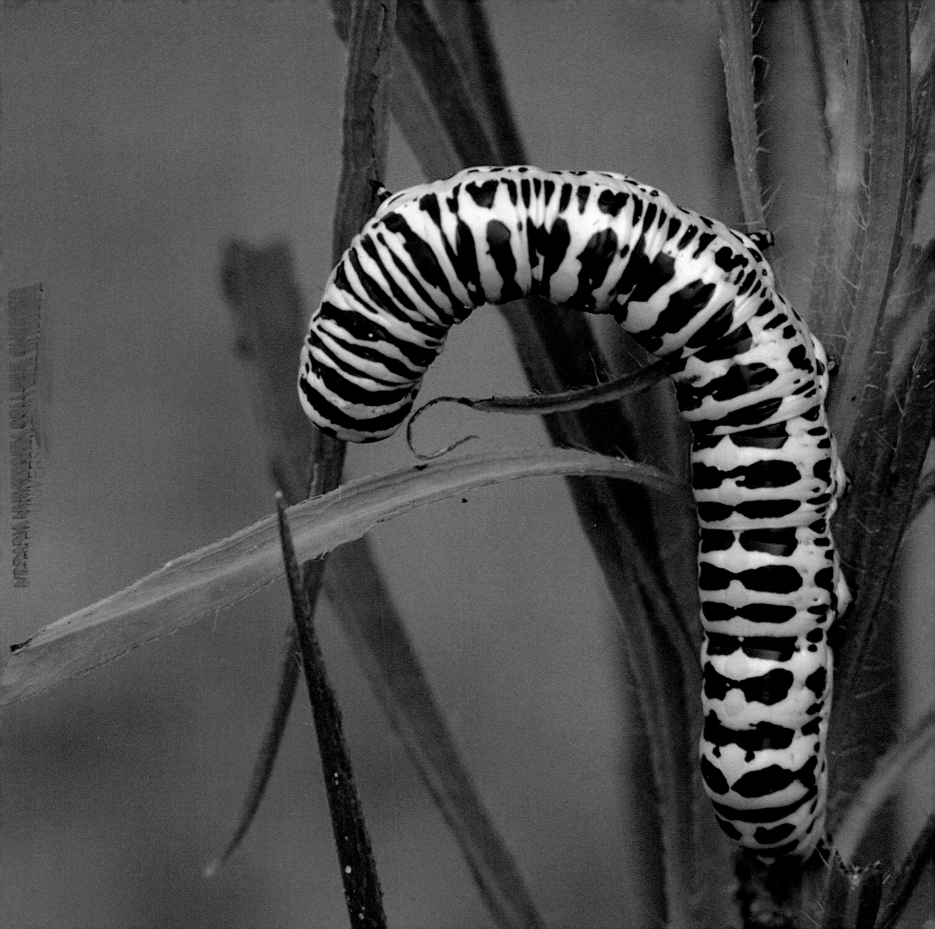

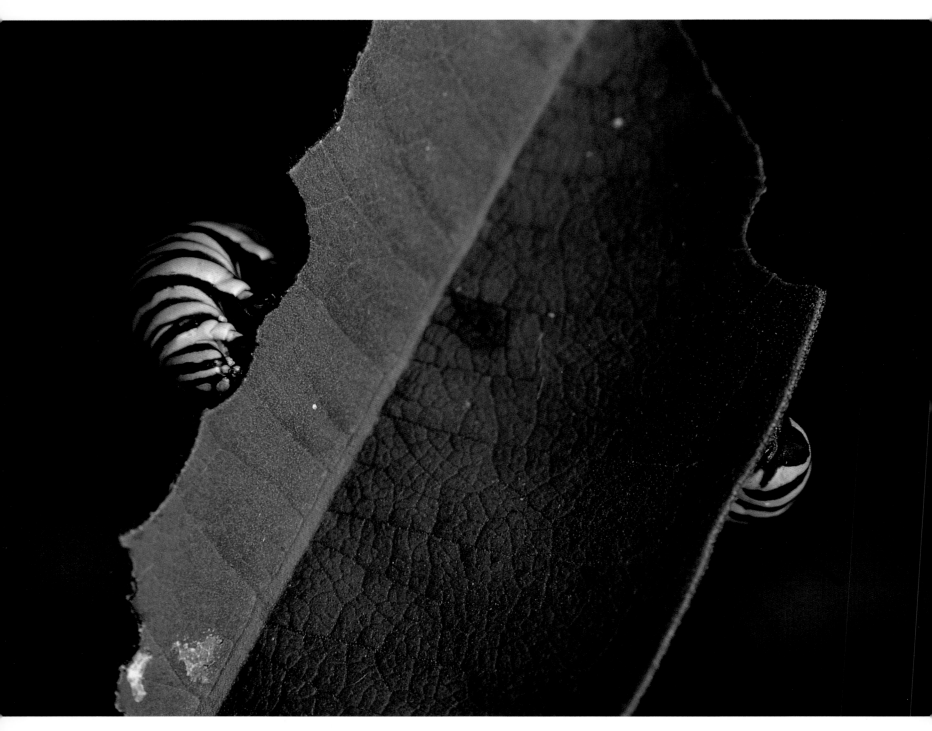

Plants often contain toxins that must be neutralized. Monarch caterpillars safely consume the leaves of milkweeds, many of which are laced with nasty heart poisons.

enormous mandibles, bearing tough, toothed edges and grinding surfaces, carve easily through most plant tissues. The razor-sharp incisors of rabbits, hares, and rodents neatly snip off twigs and bark, while their broad cheek teeth (molars and premolars) grind and shred it.

The mouths of most mammalian herbivores are functional masterpieces. Not only do the incisors grow continuously, they also self-sharpen due to the hard outer enamel and soft inner dentine components that wear at different rates as the teeth rub together. Between the incisors and the cheek teeth lies the diastema, a gap that enhances the tongue's ability to manipulate food. The diastema also enables Beavers, Muskrats, and other rodents to chew with their lips closed behind the incisors, thus preventing wood chips or water from entering the throat. The cheek teeth are fused into ridges separated by a cement. Powered by massive masseter muscles, these formidable crushing tools wear unevenly, creating an arrangement of sharp edges on flat, grinding surfaces.

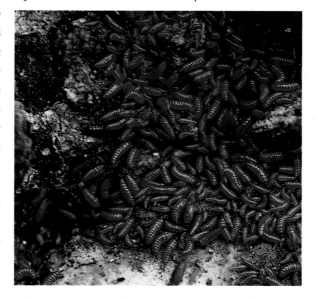

All plants are food for some type of animal. Fungus is eagerly devoured by a wide range of animals, including small insects, such as these Fungus Gnat larvae.

But not every plant-feeder possesses all these tools. Large deer such as Moose and White-tailed Deer browse plenty of woody material but lack upper incisors. They have no difficulty in nipping off twigs, however, because a tough plate on the palate provides a solid surface for their lower incisors to work against.

Other plant parts, such as seeds, present quite literally tough problems for animals to crack. Cheek teeth in mammals nicely solve any difficulty in getting at the seed's nutritious contents. A number of birds also eat seeds but lack any teeth. Instead, they resort to other tools. Northern Cardinals and other seed-eating finches have horny mounds and ridges on the inside of the beak that work in conjunction with the sharp edges of the mandibles to shell and crush seeds. Powered by oversized jaw muscles that wrap around the skull, a finch beak can deliver up to 88 pounds (40 kg) of pressure, sufficient to break open the toughest seed case.

Birds also possess another structure that serves essentially the same function as cheek teeth. The gizzard, a thick-walled, rough-textured part of the stomach, is a vital aid for dealing with tough foods. Inside this muscular organ, forceful contractions grind grit or small stones (swallowed by the bird) against seeds, nuts, or conifer needles, crushing them into small, more easily digested fragments.

Whether the animal possesses a radula, cheek teeth, mandibles, or a gizzard, the result is the same— fragmented plant material. This physical degradation is a necessary prelude to a more complete chemical breakdown. Enzymes are necessary to release the basic nutrients locked up in plant tissues. However, surprisingly few animals possess the proteins necessary to break down a plant's structural components to their basic units. Slugs and snails are among the few exceptions that produce cellulose-splitting enzymes, an advanced feature not found in most "higher" animals. Only a few insects, including certain Long-horned Beetles, Bark Beetles, and some caterpillars, also have this enzymatic capability.

If this feature is so rare in the animal world, how then do all the other herbivores digest their food? As expected, animals have managed to overcome this obstacle with not

one but a number of novel solutions. The caterpillars of thousands of species of moths and butterflies compensate for their inability to digest plant tissues fully by simply eating more of them—consuming as much as three to four times their body weight in leaves every day. To put this into proper perspective, in order to achieve the same ratio of body weight to food, being 200 pounds (90 kg), I would have to eat about 3,000 Big Macs daily! Because their digestive capability is limited, caterpillars waste a considerable portion of what they ingest, and this is reflected in the amount and bulk of their feces. Anyone who has kept a caterpillar in a jar with food, or has stood in a hardwood forest on a still summer night listening to the rainlike sound of caterpillar droppings striking the forest floor, will be aware of this characteristic. However, what is waste to some animals is food to others, and caterpillar droppings are an important source of nutrients for many smaller animals.

Large herbivores could never afford to waste as much of what they ingest as caterpillars do. To sustain their bodies' nutritional demands, they must glean as much nutrition as possible from every meal. But since they cannot produce the enzymes necessary for plant digestion, most rely on assistance from other organisms with that ability. Many herbivores harbor symbiotic colonies of bacteria and protozoans in their gut. Moose, Elk, other members of the deer family, goats, and sheep maintain a microbial colony in the rumen, the first of their four stomach chambers. Once the plant matter is chewed by the cheek teeth, it is swallowed and enters the rumen. Here, bacteria and protozoans work on the material, releasing important nutrients. But complete digestion cannot occur until the food is more fully degraded. So a cud is regurgitated and once again ground by the cheek teeth. Cud-chewing often occurs while the animal leisurely reclines in a safe refuge, away from the eyes of predators. After more complete mastication, the food is swallowed again. This time bacterial action is more complete, and the food continues down the digestive tract, where the liberated nutrients are absorbed.

Other non-ruminating herbivores process their food twice, only in a much different fashion. Hares, rabbits, and Beavers house their symbionts internally in saclike extensions of the intestine (caeca). Because the microbial action takes place so late in the digestive process, only a small portion of the nutrient value is extracted before the material leaves the body. For example, rabbits only digest about eight percent of grass cellulose on the first pass through their digestive tract. However, these frugal animals implement a "waste not, want not" policy and devour their soft, nutrient-rich droppings. After a second pass through the animals, the waste material (now in the form of hard pellets) contains four times less protein than found in the initial soft excretions. Although feeding on excrement (coprophagy) may seem a somewhat unsavory way to obtain nutrients, it is just another means of extracting the maximum amount of nutrition from the stingy tissues of plants.

In addition to the physical challenges that plants present, most are laden with toxins that must be neutralized or eliminated. To counteract these toxins, many animals are equipped with detoxification systems that incorporate special enzymes, including mixed-function oxidases. MFOs are usually found in specific sites, such as the livers of vertebrates and the midguts of insects. In many animals, the same symbionts responsible for breaking down the plant's structural components also perform detoxification.

Locked in a never-ending game of ecological chess, animals counter the formidable defenses of plants with a variety of imaginative offenses. Tools for piercing, sucking, tearing, crushing, detoxifying, and digesting are not only commonplace but extremely diversified. Yet, although animals do on occasion demonstrate overwhelming power through local defoliation episodes, our largely green world is testimony that plants still hold the upper hand in this eternal battle for existence.

Red Crossbills and other seed-eating finches pulverize seeds in their gizzards with the aid of grit.
While marvelously designed for extracting seeds from under pine cone scales, the unique crossed mandibles of these nomadic birds
make the task of picking up stone fragments a problematic one.

CHAPTER FOUR

TO KILL OR NOT TO KILL

WITH GREAT INGENUITY, HERBIVORES HAVE CONQUERED the physical and chemical deterents offered by plants. But other animals have resolved the plant digestion problem in a quite different fashion. By deriving their essential nutrients from the bodies of herbivores and other animals, predators and parasites directly bypass the challenges presented by plant tissues.

Although both of these lifestyles involve the theft of nutrients from another living being, one major difference separates the two. When prey is eaten by a predator, death always results; on the other hand, parasite hosts usually survive even heavy infestations. To kill or not to kill was the dilemma that sent these two successful strategies down different evolutionary paths.

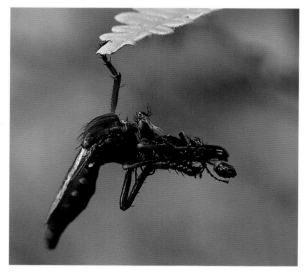

The poison injected by Robber Flies not only immobilizes the prey but also starts digesting its insides into an easily sucked protein milkshake.

Predation definitely has its advantages: plant defenses are bypassed and food is much easier to digest and assimilate than unwieldy plant tissues. As with any solution to any obstacle, there are also major disadvantages. Unlike plants, animals are often less predictable and more difficult to locate. The effort expended in capturing and killing one's quarry can be considerable, especially if the anticipated meal fights back. During such struggles, serious, even fatal, injuries can be inflicted. A predatory life is fraught with accidents and hazards, including the bodily accumulation of toxic chemicals, such as DDT. Throw persecution by humans into this cauldron and a predator has an even lesser chance of surviving.

But just as plant eaters — the primary consumers — waste much of their food's nutrient value, animal predators also fail to use all of the nutrients that they consume. When a secondary consumer, such as a Deer Mouse, eats a caterpillar, both nutrients and energy are lost in the transfer. When a Short-tailed Weasel—a tertiary consumer—eats that mouse, nutrients and energy are lost again, and still more when a Red-tailed Hawk devours the weasel.

Because of this inefficiency, and since many predators are larger than their prey, if all the different animals for each feeding level were placed on top of one another, starting with plant consumers at the base, a pyramid would be the result. This is due to there being fewer animals

All predators, including this Barred Owl, need special adaptations for locating, capturing, killing, and consuming their prey.

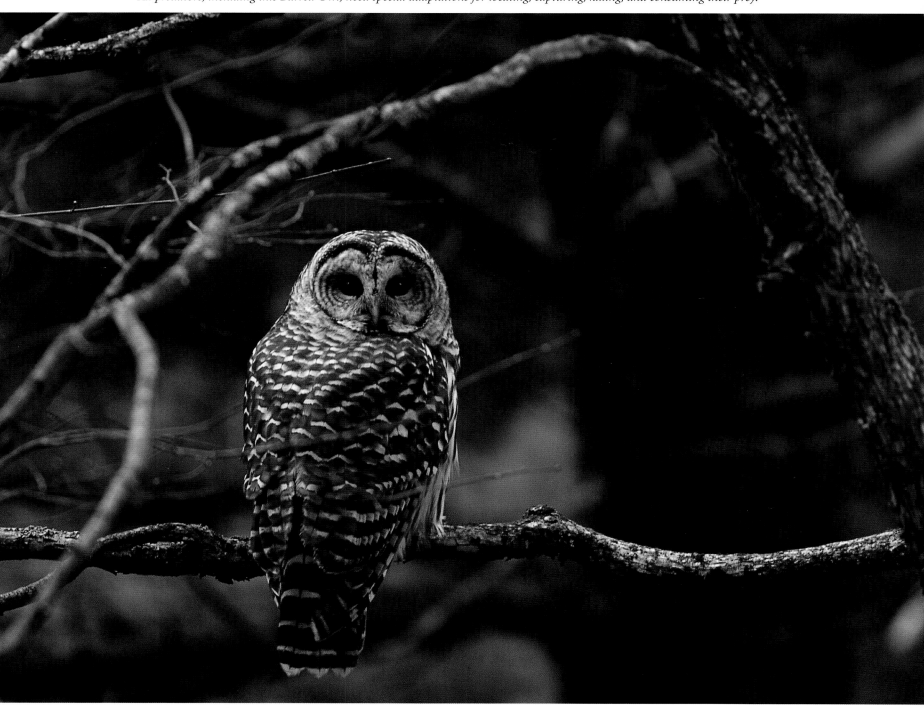

TO KILL OR NOT TO KILL

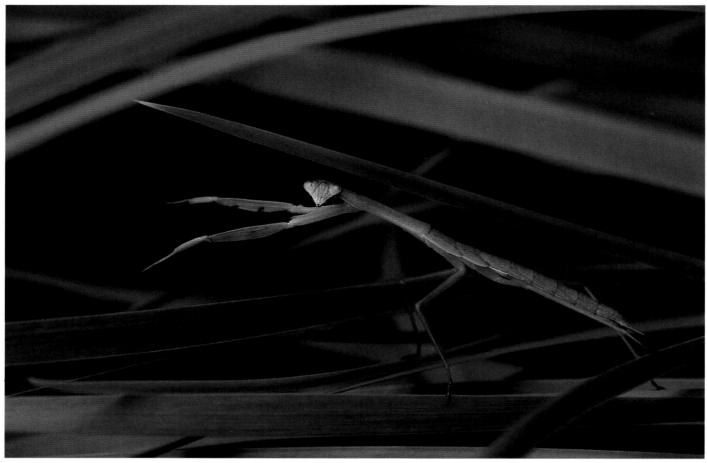

Praying Mantids (above) and Crab Spiders (opposite) depend on cryptic coloration and behavior for prey capture.

at each higher level of the consumer hierarchy. Inevitably, there are never enough resources available to support more predators than prey.

Before predators can enjoy a meal, they first must find it. To resolve this initial obstacle, many prefer to let their food come to them, and employ a hide-and-wait style of hunting. Disruptive patterns and cryptic coloration and behavior—the very same principles adopted by prey to elude predators—characterize hunting by ambush. Praying Mantids silently blend into the stems and leaves on which they rest. With lethal patience, Crab Spiders wait on the floral blooms they emulate in color and form. Red-tailed Hawks sit con-

cealed on lofty perches, waiting for their prey to make a fatal move. Even aquatic predators exhibit these traits. The mighty Muskellunge lurks in weedy patches, its vertical bars rendering it virtually invisible to its unsuspecting victims.

Other predators actively seek out their prey. Wolf Spiders, Jumping Spiders, centipedes, many songbirds, including the beautiful wood warblers, and wild dogs such as Red Foxes all hunt by "search and capture."

Different groups of animals often hunt the same terrain in similar fashion but at different times of the day. Where Tiger Beetles pursue meals under the blazing sun, Ground Beetles stalk their quarry by moonlight. At dusk,

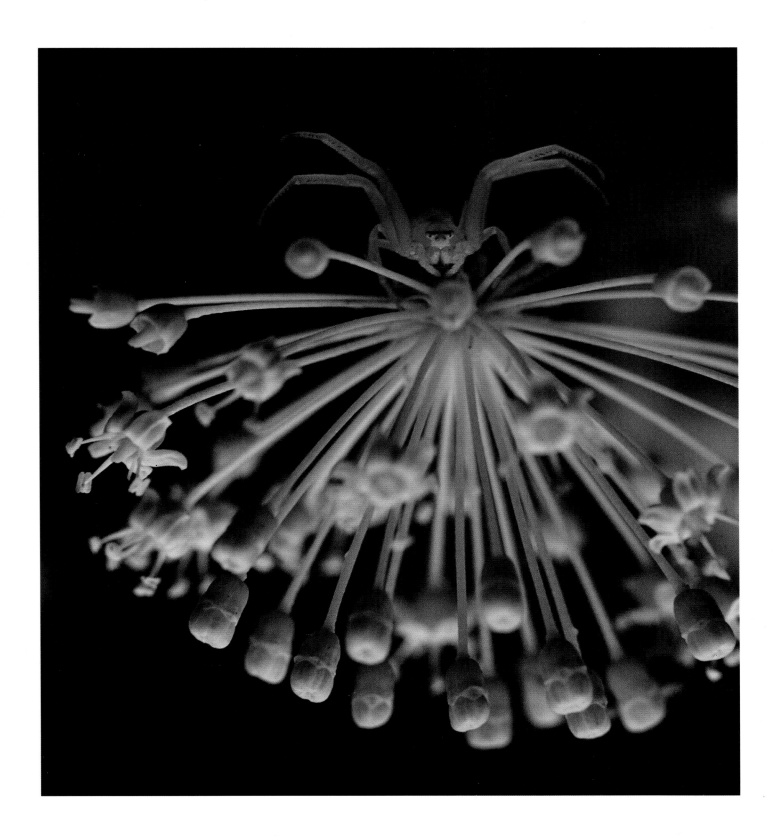

TO KILL OR NOT TO KILL

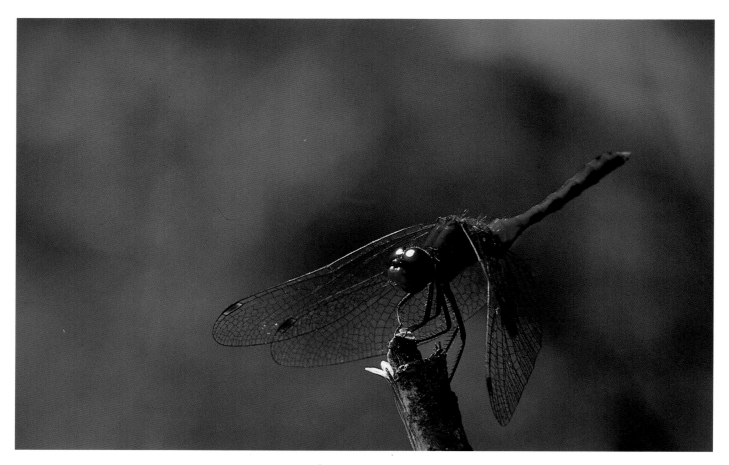

Large eyes are typical of hunters, including Meadowfly dragonflies (above) and Bullfrogs (opposite),
whether they hunt by day or by night.

Long-eared Owls flit over the same meadows where Northern Harriers soared at high noon. But no matter what time of day is preferred, every hunter relies on special aids to find and capture its elusive prey.

To varying degrees, the senses of sight, hearing, and smell are important for locating prey. Many daytime hunters—dragonflies, Tiger Beetles, and Jumping Spiders, for example—have particularly large eyes loaded with sensory cells for acute vision. By far, though, the best vision in animals can be found in birds of prey. The incredible vision of hawks and eagles—several times more acute than ours—is due to several modifications.

Their proportionately huge eyes are packed full of cones, sensory cells for color vision and visual acuity. Two retinal pits or fovea each contain as many as one million cells. As well, a flattened lens situated a good distance from the retina effectively enlarges the incoming image. These special eye adaptations enable Golden Eagles to spot their quarry up to a mile (2 km) away!

Although the detection of a potential meal is important, predators must also be able to judge with accuracy the distance between them and their victim before capture can be made. Many predators' eyes are located toward the front of the head, a placement that increases

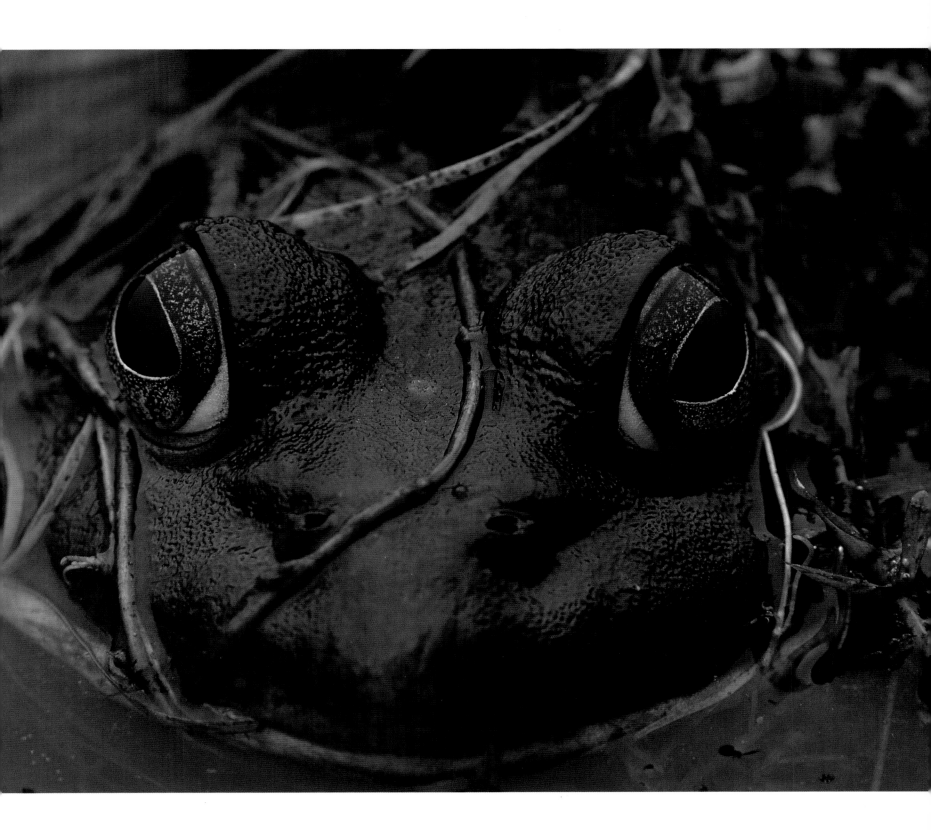

depth perception essential for determining the distance to be overcome by that final dash, leap, or flight. Each eye has a certain field of view, and forward eye placement increases the overlap of these fields, thus enhancing depth perception or binocular vision. Owls have about 60 degrees of overlap; cats roughly double this figure. On the downside, forward eye placement creates a large blind spot behind the animal. Because this would be fatal for animals trying to avoid predators, most prey species have eyes on the sides of their heads for greater peripheral

vision. Pigeons have a 300-degree field of vision, almost double that of owls, but as a result their binocular field is only 30 degrees. Rabbits have no blind spot at all—their field of view is a full 360 degrees—and only 10 degrees of binocular vision to the front and to the back. Indeed, rabbits would go hungry if they were hunters dependent on binocular vision for capturing prey!

Whether a hunter or the hunted, all animals that are active at night must cope with the problem of limited light. While large eyes are useful for collecting light, other

(Opposite) The dishlike face of Great Gray Owls and their relatives is an aid for hearing distant prey. Sounds hitting the facial feathers are directed to the ear openings by concentric rings of hard feathers.
Snakes, including this Black Rat Snake (below), compensate for an absence of external ears with a highly developed olfactory sense. Scent molecules are collected by the forked tongue, which may help to pinpoint the precise direction of the odor's source.

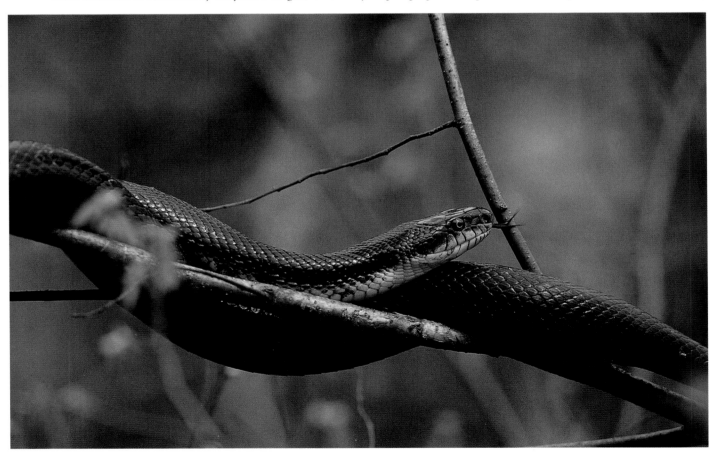

adaptations are essential for seeing well in the dark. In many nocturnal animals, the eyes are packed with rods, sensory cells responsive to low light levels. Another adaptation is one that causes an animal's eyes to glow when illuminated by a car's headlights. The eyeshine is created when the light strikes the tapetum lucidum, a layer of reflective cells behind the retina. In general, a certain amount of the light entering an animal's eye fails to strike the sensory cells and so is not used. But nocturnal animals cannot afford to waste any of the scant light offered to them. Because of the tapetum lucidum, light that fails to strike a sensory cell is given a second chance when it is reflected back into the eye. Interestingly, eyeshine varies in color from animal to animal, which is why the eyes of a Red Fox glow green and the Whip-poor-will's blaze red.

While eyesight is important, many animals depend also on hearing to locate prey. In fact, for some, hearing is their primary means of hunting. Using a system called echolocation, insect-eating bats sweep the air with bursts of ultrasound. Within milliseconds of bouncing off a moth, the sound waves are analyzed in the bat's computerlike brain, and the winged creature quickly homes in on its prize—that is, unless the insect is one of the few equipped with defenses to combat the bat's ultimate

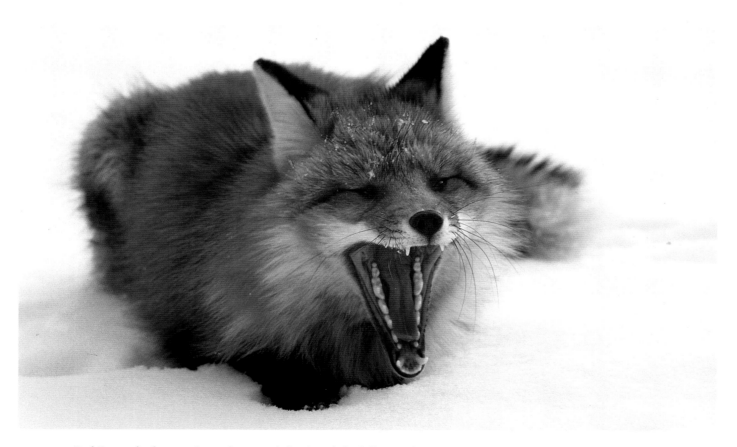

Red Fox and other carnivores have specialized teeth for killing and eating their meals. The large canines catch and kill the prey, while the carnassials help to slice it up.

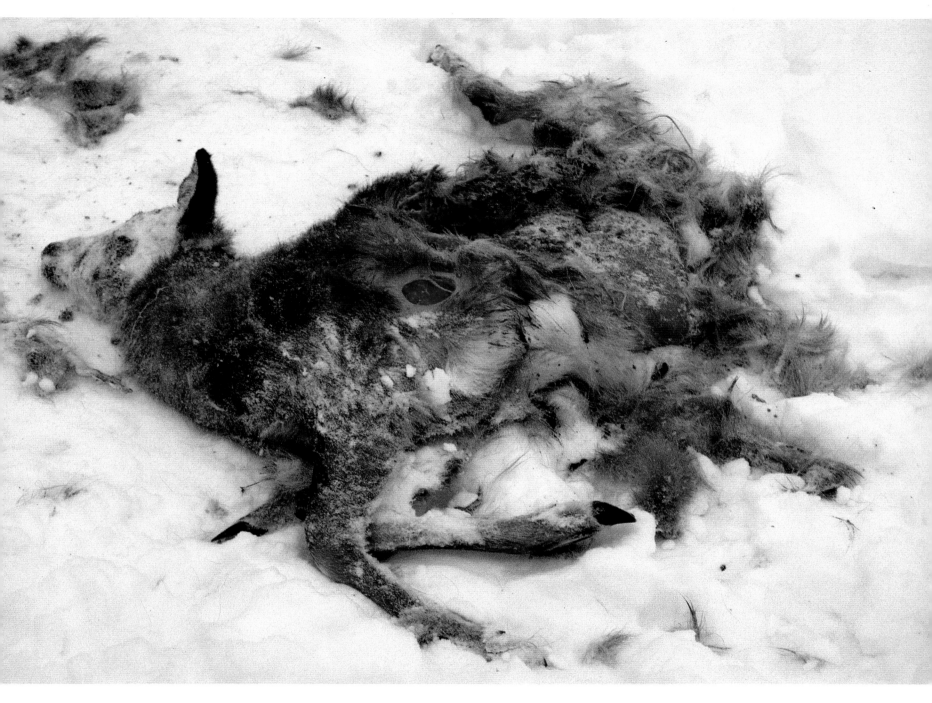

The killing of a White-tailed Deer by Gray Wolves is no different than the eating of a Hover Fly by a Crab Spider or clover by a Woodchuck; it is merely a means of acquiring essential minerals.

TO KILL OR NOT TO KILL

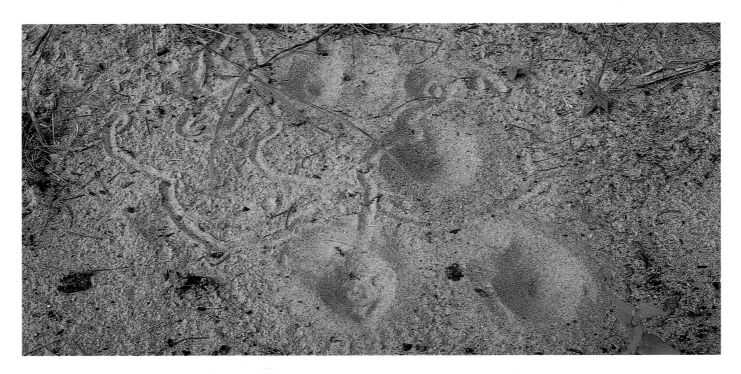

The larvae of Ant-lions construct conical sand traps under which they lie concealed and waiting. When a prey slips into the pit, the Ant-lion suddenly bursts through the sand, grabs the hapless victim with its poison-injecting mandibles, and quickly drags it out of sight.

detection system. A number of insects have built-in alarm systems in the form of "ears" (drumlike organs in their bodies, legs, or wings) that are sensitive to bat calls. Certain Tiger Moths not only detect bats but also produce batlike sounds with a special clicking device, confusing their aerial foes in the process..

For most of the animals that lack the sophistication of a bat's auditory system, other adaptations have proved almost as effective. Many predators are sensitive to higher frequencies of sound, such as the squeaks of mice, and have large, highly movable external ears that pick up and magnify distant noises. Owls have a couple of ingenious adaptations that enable many members of this group to pinpoint accurately the location of their prey in darkness. The ear openings, large asymmetrical slits on either side of the broad head, are vertically offset. This imbalance causes a sound to arrive in the inner ears at slightly different times; a mere three ten-thousandths of a second

The strongest traps in the world are the silken webs of spiders.

difference is sufficient for the owl to pinpoint the origin of a sound. An owl's facial feathers also aid in detecting the faintest rustling. The concentric facial rings or disks formed from dense feathers direct sound towards the skin flaps encompassing the ear openings.

For many hunters, the prey's scent adds another dimension to the detection of food. Snakes cannot hear because of a lack of external ears, and so depend heavily on their olfactory capabilities for gleaning information about the world around them. Their nostrils open into a chamber partly lined with a large sensory tissue. They also detect prey by smelling or "tasting" the air with their tongue. After picking up airborne scent molecules, the tongue delivers the sample to the Jacobson's or vomeronasal organ, a mass of sensory cells housed in the roof of the mouth. Here, the molecules are quickly analyzed. Besides detecting odors, the Jacobson's organ may also help to pinpoint the prey's location by discriminating a subtle chemical gradient existing between the two forks of the tongue. Thus, a snake's tongue may actually serve a similar function as the offset ears of an owl!

Although mammalian powers of smell are not as refined as that of snakes, the elongated snouts of many species house large numbers of sensory cells, particularly in the vomeronasal region. Predators are often active when scents are most easily detected and followed. Dusk is a favorite time, as telltale odors linger near the ground's surface, held because the soil remains slightly warmer than the air above it. Mammals are not the only ones that locate prey by odor. Ground Beetles, for example, track down snails and slugs by following the slime trails left by these slow-moving animals.

But what about those predators that inhabit environments where light is absent and scent carries poorly? Here, the sense of touch acquires elevated status over sight and smell. As moles tunnel through their world of darkness, tactile or sensory hairs on their snouts and tails inform them of the presence of earthworms and other delectable meals. Coarse sensory hairs (vibrissae) fringing the mouth help River Otters locate crayfish hiding along the murky bottoms of streams and rivers.

In their search for prey, a number of predators employ

rather sophisticated detection systems. Heat sensors in pits between the eyes and nostrils of a rattlesnake are so sensitive to the infrared wavelengths of heat that they can detect a mere one-thousandth of a degree Fahrenheit (.05 of a degree Celsius) change in temperature! A prey's movements in the water alert aquatic predators to its presence in a couple of ways. The lateral lines of fish detect pressure changes, while the foot sensors of Water Striders are sensitive to disturbances on the water's surface. And when water ripples activate a sensor called the Johnston's organ by spreading apart its antennae, a Whirligig Beetle is alerted to the presence of a potential meal.

To draw their prey within striking range, a few animals employ a most novel method of attraction known as aggressive mimicry. Just as a fisherman offers bait on a hook, an Anglerfish dangles a fleshy appendage in front of its gigantic, gaping mouth. When an unsuspecting fish goes for the lure, the massive trap snaps shut. Alligator Snapping Turtles entice gullible fish within reach of their lethal jaws by wriggling a wormlike structure on their tongue. As a hunting technique, aggressive mimicry is executed in a somewhat different manner by a predatory Firefly. The hungry beetle sneaks into an area where males of a non-predatory species are flashing their desire to meet willing females. Into the darkness the predator deviously flashes the coded response so eagerly anticipated by the performers. But when a lovestruck male swoops in for his reward, the only liaison awaiting him is a rendezvous with death.

Locating the prey is only part of the battle; capturing and immobilizing it also requires considerable effort. The mouths of many predators are instrumental in this process. Mergansers (a group of diving ducks) have serrated bills for grasping slippery fish, and Tiger Beetles bear sickle-shaped mandibles that hold and shred their catch. Flying prey are more readily captured by animals that have an enlarged mouth. The modified feathers at the base of the beak help to funnel insects into the open mouths of Common Nighthawks, Whip-poor-wills, and swallows. These rictal bristles may also serve a tactile role, particularly for flycatchers, in informing the birds of the presence of a meal.

Woodpeckers use their beaks to access the food while their tongues do the actual capturing. The extremely extensible tongue originates near the opening of the nostril and almost encircles the woodpecker's skull. Sticky saliva on this lengthy tool enables the bird to extract an insect from even the remotest location. Amphibians also have quite impressive tongues, with a frog's nearly doubling in length once it is unfolded and flicked out at a passing fly.

Carnivores are extremely proficient killing machines, mainly because of their canine teeth. These large conical teeth, powered by massive temporalis muscles, usually deliver the death bite. However, considerable creativity is displayed in the way carnivores use these deadly teeth: weasels smash the brain case by piercing the back of the victim's head; cats separate the cervical vertebrae with a lethal bite to the neck; Gray Wolves slash large prey until it is immobilized and enters shock; and Red Foxes and Coyotes grab small prey by the scruff of the neck and shake it until the neck snaps (a technique I call "shake and break").

While the canines are the main killing tools, another set of specialized teeth, the carnassials, is important for eating. These modified cheek teeth are sharply flattened on one side for shearing muscle, tendon, and bone. When a domestic dog happily gnaws on a bone, its carnassials are behind that delightful cracking sound.

Legs can also be used as tools of capture. A thick brush of sticky hair (the scopula) on the appendages enables

This Sphinx Moth caterpillar was consumed internally by Braconid Wasp larvae, now pupating in their cocoons. Because their hosts are killed by their feeding efforts, these wasps are called parasitoids.

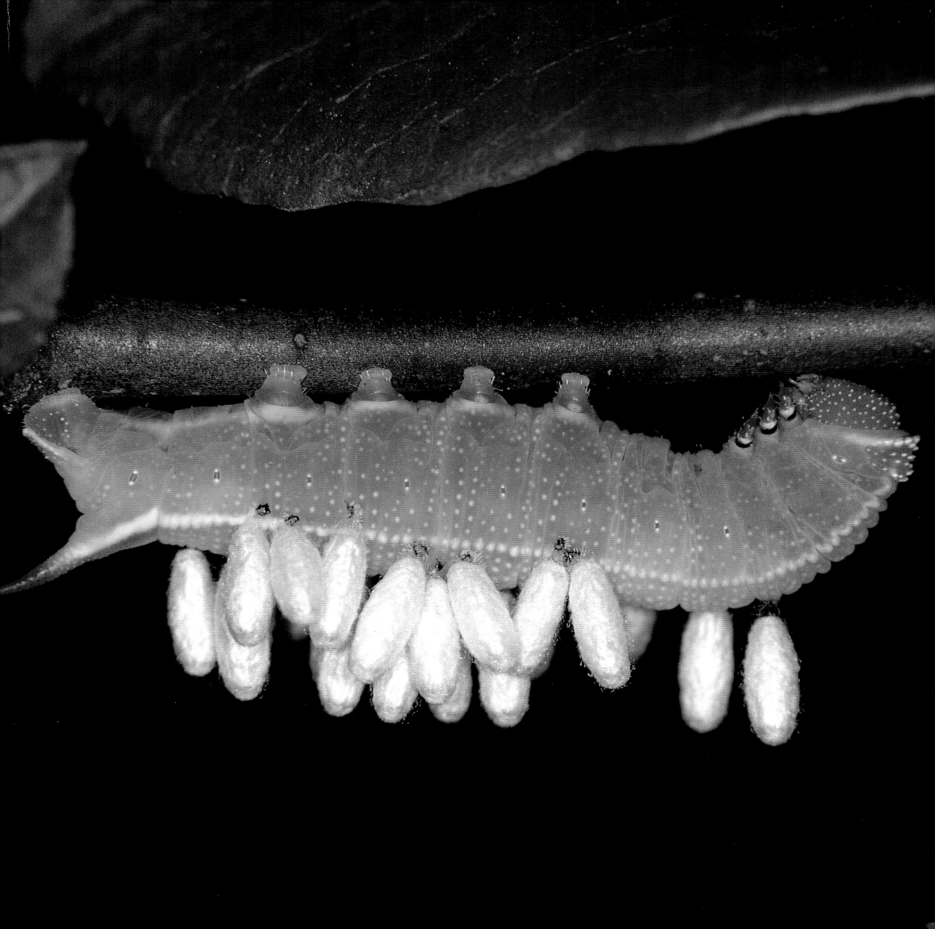

spiders to snatch flies with great dexterity. Praying Mantids and Water Scorpions snare prey with a snap action of their spined, raptorial legs. A basket formed by spines and hairs on the first pair of legs is used by dragonflies to scoop insects from the air. For most birds of prey, the feet are their sole means of catching prey. Owls and fish-eating Ospreys have a reversible outer toe, an aid for plucking elusive prey from dark recesses. Ospreys also bear a pad of sharp spines on the soles of their feet—an aid for grasping their slippery meals.

Feet may serve to kill as well as capture. Cooper's Hawks and other accipiters squeeze their victims to death, puncturing vital internal organs with their long, sharp talons. At incredible speeds, Peregrine Falcons dive at their quarry and rake it with their claws, either tearing it open or breaking its neck on contact.

Snakes lack developed limbs and so must use their mouths to capture and process their food. All species can swallow animals much larger than their heads. With a ratchetlike motion, they are able to move each side of their jaws forward and back independently, walking their mouths over the prey. While Garter Snakes and Water Snakes slowly swallow frogs and other animals alive, Milk Snakes and Fox Snakes quickly suffocate their prey before eating it. These constrictors wrap their bodies around an animal, steadily tightening their coils whenever the victim exhales.

Other snakes, including rattlesnakes, are well known for their use of poison. The advantages of this method to its user are multiple: a snake can immobilize large and dangerous prey at reduced risk of injury to itself; less energy is expended in both capturing and swallowing the meal; and enzymes in the venom initiate the digestive process. In the animal world, however, poison is not unique to snakes. Centipedes, spiders, Assassin Bugs, Robber Flies, Backswimmers, Ambush Bugs, and Short-tailed Shrews all use poison bites to subdue their prey.

In their efforts to capture prey, predators may use quite ingenious methods. Unquestionably one of the most inventive techniques is the use of traps. Several types of spiders, particularly Orb-weaving Spiders and Sheet-web Spiders, produce elaborate webs of sticky silk that are the fate of many a flying insect. One southern species, the Bolas Spider, actually swings a ball of sticky silk at passing insects, and, once a direct hit is made, reels in its prize, just like a fisherman hauling in his line. Some Bolas Spiders even coat the silk ball with a chemical resembling the love potion of a female moth, luring hopeful males of that insect to a certain death.

A quite different trap is made by the larvae of Ant-lions, which resemble some bizarre creature out of a Stephen King movie. These oar-limbed insects construct conical pits in the sand and then lie submerged in deadly wait at the very bottom. When an ant or some other insect stumbles into the pit, knocking sand grains to the bottom, the Ant-lion immediately springs into action. Bursting through the sand, the creature snaps its massive mandibles at the intruder. Even if the animal manages to elude the first attack and scramble partway up the slope, escape is temporary. With its formidable mandibles, the Ant-lion scoops sand at it, eventually knocking it to the bottom of the cone. It then seizes the victim by its poison-injecting mouthparts and quickly drags it beneath the sand to an unobserved fate.

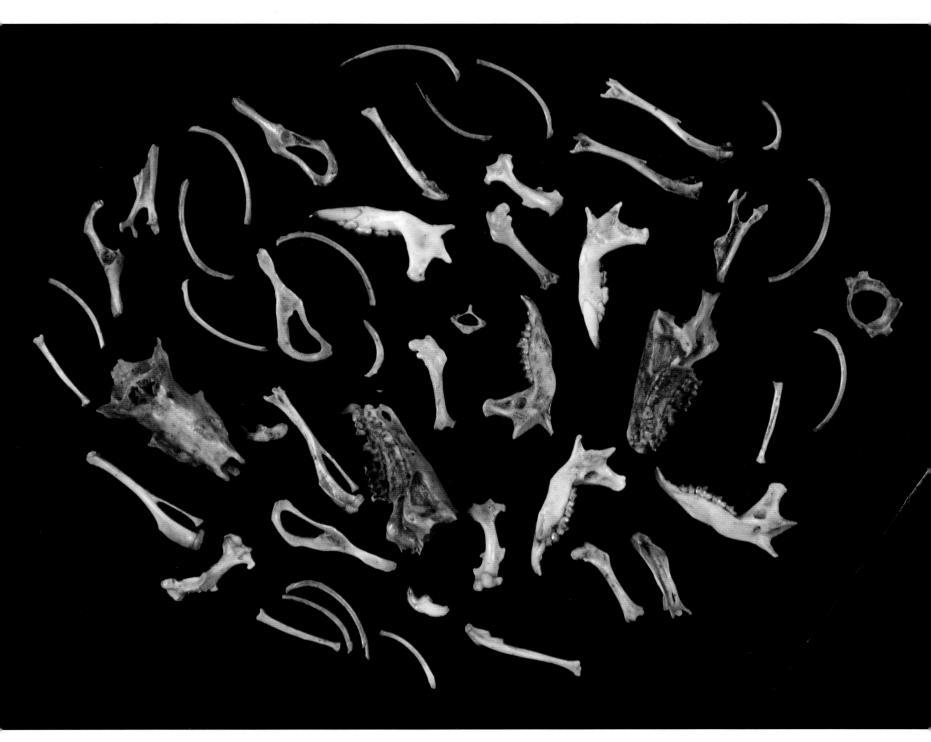

Owls and other predatory birds have resolved the problem of dealing with the bones, fur, and other indigestible parts of their prey by regurgitating them as pellets. (Opposite) This Barred Owl pellet held the skulls and bones of three Short-tailed Shrews (above).

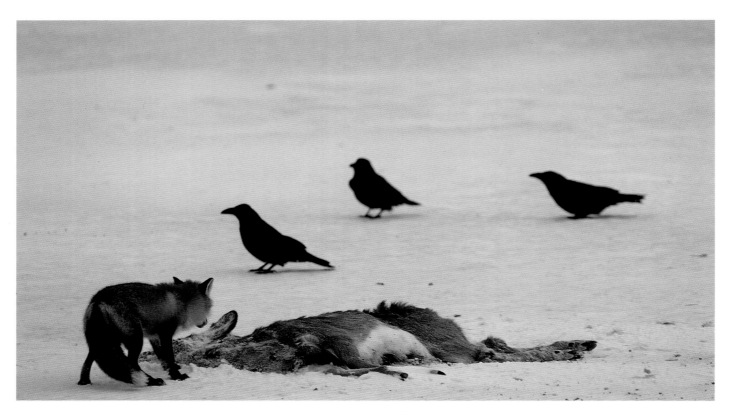

The death of a large animal supports more than those that killed it, for an entire army of animals scavenges the leftovers. In nature, nothing is wasted.

Once its prey is captured, a predator must then tackle the problem of digesting it—not as simple a task as one would think. Animal tissues are usually easier to digest than those of plants, and enzymes created by the pancreas and other organs easily break down much of the material. But some components, such as the chitin found in the outer skeleton of insects, as well as bones, feathers, and hair, are difficult to digest and require special attention. Spiders, Robber Flies, Assassin Bugs, and other predatory insects sidestep the problem by sucking the inner liquid out of their invertebrate prey and then casting away the lifeless shell. Bears avoid the hair of larger prey, such as moose calves, by pulling the hide off the carcass. Hawks often use their hooked beaks to pluck the feathers from birds they have captured before picking the flesh off the bones.

But there are predators that swallow mice, voles, fish, and other small prey whole, all body parts intact. A number of predatory birds, including owls, hawks, grebes, and herons, deal with the indigestible portions by regurgitating them in the shape of oblong pellets. In the gizzard, all bones, hair, and other inedible parts are separated from the flesh, wrapped together into a pellet, then coughed out. Wolves and Coyotes, on the other hand, pass the small indigestible parts through the entire system, but any potentially harmful item, such as a bone, is thoroughly wrapped in hair.

The bodies of others are a source of nourishment for many animals. But not always does an animal die when it is exploited as a food source. In fact, thousands of parasitic species steal nutrition from other creatures without

inflicting serious damage. As it would be suicidal to kill the animal on which their existence depends, parasites rarely kill their hosts. Some even destroy their host's sex drive in a process called parasitic castration, in an effort to prolong its life. Indeed, parasitism is a highly advanced feeding strategy.

If the host's fate is the criterion for separating parasitism from predation, then a number of insects have been misclassified as parasites. Many "parasitic" insects, such as Braconid Wasps, Ichneumon Wasps, and Tachinid Flies, lay their eggs on caterpillars and beetle grubs. Upon hatching, the larvae set to devouring the host. But since the host fails to survive the ordeal, it is best to call these insects "parasitoids" to separate them from true parasites, which do not kill their source of food.

Compared to the animals they exploit, parasites are extremely small. But despite their tiny size, many internal parasites (endoparasites) — roundworms, tapeworms, and flukes, for example—lead quite complex lives. Many change host animals during their lifetimes. The brainworm, a roundworm that eventually resides in White-tailed Deer, spends part of its life inside a snail. A deer first acquires the parasite by ingesting a leaf that carries an infected snail. Inside the deer's digestive tract, the brainworm leaves the snail and exits the gut, eventually traveling up the spinal column to the head. Here, in sinuses near the brain, the parasite thrives and reproduces. Eggs are passed from the deer's respiratory tract into the digestive tract, and, eventually, the larval stage passes out with the droppings. When a hungry snail pauses to feast on the juicy morsels, the parasite penetrates its foot. The snail eventually seeks out a leaf on which to feed. When the leaf bearing the snail is devoured by a deer, the cycle becomes complete. Because the brainworm reproduces only in deer, that animal is

the definitive host and the snail is the intermediate host.

Parasite/host interactions often reach incredible heights of complexity. One type of fluke uses American Robins as the definitive host. The parasite passes out with the bird's droppings and infects an aquatic snail if it happens to land in a puddle of water. The fluke then moves into this host's antenna, causing it to swell, change color, and vibrate noticeably. When the snail crawls up on vegetation in daytime (because of a behavioral switch from night to day activity), the infected antenna acts as a lure, attracting the attention of another Robin. The bird bites off the antenna (probably in the belief that it is an edible grub) and stuffs it down the throat of one of its nestlings — unknowingly completing the cycle for this phenomenal parasite.

Certain leeches, fleas, lice, ticks, mites, and fish (lampreys, for instance) that live on the outside of larger animals are known as ectoparasites. Like endoparasites — their internal counterparts—they may specialize on only one type or group of animals. However, they usually do not change hosts.

Predation or parasitism—to kill or not to kill—are common feeding strategies. But they are by no means the only options available to animals that exploit others for their food. A few also derive a living by feasting on the dead. Through a number of internal adaptations, vultures and gulls are able to dispose of putrid corpses, regardless of how long they have been decomposing. Carrion Beetles and Blow Flies seek out smaller cadavers, either as food for themselves or for their offspring.

An animal can be used as a source of food in an astounding number of ways. This tremendous variation in feeding strategies exemplifies the principle that, in the animal world, every opportunity is exploited. When it comes to eking out an existence, Nature is truly the master of frugality.

CHAPTER FIVE

THE GREAT ESCAPE

ALL FOODS, WHETHER THEY CONSIST OF PLANTS OR ANIMALS, can at times be hard to find. Often the droughts are short-lived, with animals locating enough food by searching a larger area, increasing the time spent looking, or switching to another type of fare. At other times, particularly during winter in northern regions, the prolonged disappearance of food resources poses a much more serious problem. Unlike brief periods of sparsity, however, long-term food shortages associated with this season occur with relative regularity, making them somewhat predictable. It is this predictability that underlies the diverse array of survival solutions that have arisen in response to this trying time of the year.

When winter arrives, the animals of northern regions are faced with two main choices: stay active and challenge this uncharitable season, or flee from the demanding conditions that winter inevitably brings. For some animals, a blend of the two options is the best strategy. If their preferred plants produce large seed crops, many

Gray Squirrels and other mammals build up body fat and grow thicker coats to keep warm during winter. Internal stores of brown fat also generate essential heat during sub-zero conditions.

northern finches, such as Pine Siskins, Common Red-polls, Pine Grosbeaks, and White-winged Crossbills, will remain near their summering areas. But if food is scarce, the birds will adopt a rather nomadic lifestyle, seeking out seed crops often thousands of miles from their summer haunts. Crossbills, in particular, live a life closely tied to the mast crops of coniferous trees, taking full advantage of the existence of an exceptional food source by remaining to feed and breed. As a result, these highly specialized birds have been known to nest in virtually every month of the year.

Some animals travel great distances in search of resources; others stay put, making do with supplies at hand. A few also exploit food stores created during the months preceding winter. Prior to their pond freezing over, most Beavers construct a massive pile of branches close to their lodge. Beneath the ice these industrious animals retrieve poplar and other delectable branches from this food pile, feasting on them in the comfort of the lodge. While Beavers create one cen-

Many northern finches, such as these White-winged Crossbills, live a rather nomadic life in search of seed crops.
They stay to eat and even breed whenever a mast crop is encountered.

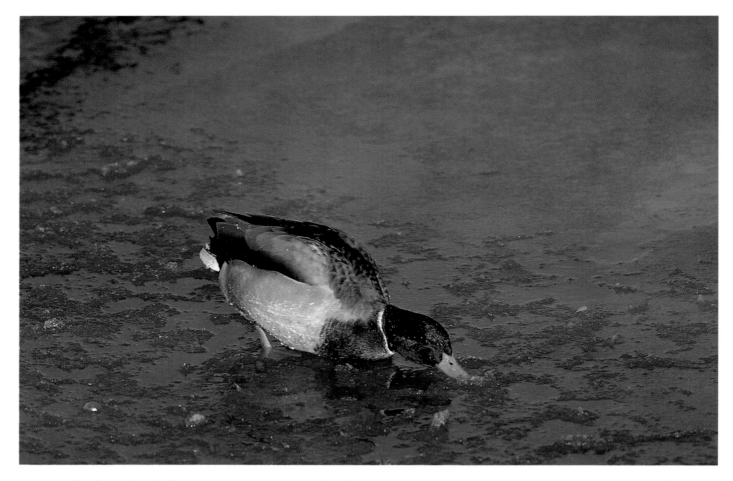

The feet and tails of animals are great sources of heat loss. But the countercurrent heat exchange system in the feet of Mallards (above) enables these animals to stand on ice or to swim in icy water with no ill effects.
For Great Gray Owls (opposite) and other inhabitants of northern regions, winter brings a number of serious challenges, including food shortages and sub-zero temperatures.

one central cache, Red Squirrels stash numerous piles of spruce cones under logs, stones, and in hollows. Heaps of cone scales on the snow later reveal the locations of these former caches. Gray Jays store thousands of morsels under lichens and the loose bark of trees. Each piece is carefully wrapped in a salival blanket, which not only glues the item to the branch but possibly aids in its preservation. Rather than create long-term stores, Black-capped Chickadees hide small amounts of excess food throughout the winter. These mini-stores provide a quick intake of calories, important when extra body heat is needed in a pinch.

During the stressful winter months, most birds face the unavoidable problem of increasing their foraging time while remaining alert for predators. A common solution to this dilemma is to travel in groups or flocks. Collectively, the group maintains almost total vigilance, allowing each bird to invest more time in feeding and

THE GREAT ESCAPE

less time in looking for predators. While competition for food increases with group size, large single-species flocks of White-winged Crossbills or other northern finches are possible because their food resources occur in large patches. For other birds, mixed-species flocks are more advantageous. Black-capped Chickadees, Red-breasted Nuthatches, Brown Creepers, and Golden-crowned Kinglets commonly travel together in winter woodlands. Because each species forages in a different way and their food occurs in small, scattered clumps, competition in the mixed group is not as intense as it would be for a large flock of any one of these species. And each individual still benefits from being in the flock, since more eyes make for increased awareness.

For those that remain active in the winter, finding enough food is one challenge; staying warm is another. Just as humans throw on extra layers to keep out the cold, winter-active animals increase their body insulation as the cold weather approaches. Fat—particularly deposits under the skin—builds up and the outer covering

Most insects remain dormant as eggs or larvae during the winter months. Compton Tortoise Shells, however, overwinter as adult butterflies. Considering that without the aid of powerful antifreezes these ectothermic animals would perish in sub-zero weather, their survival to early spring is no small feat.

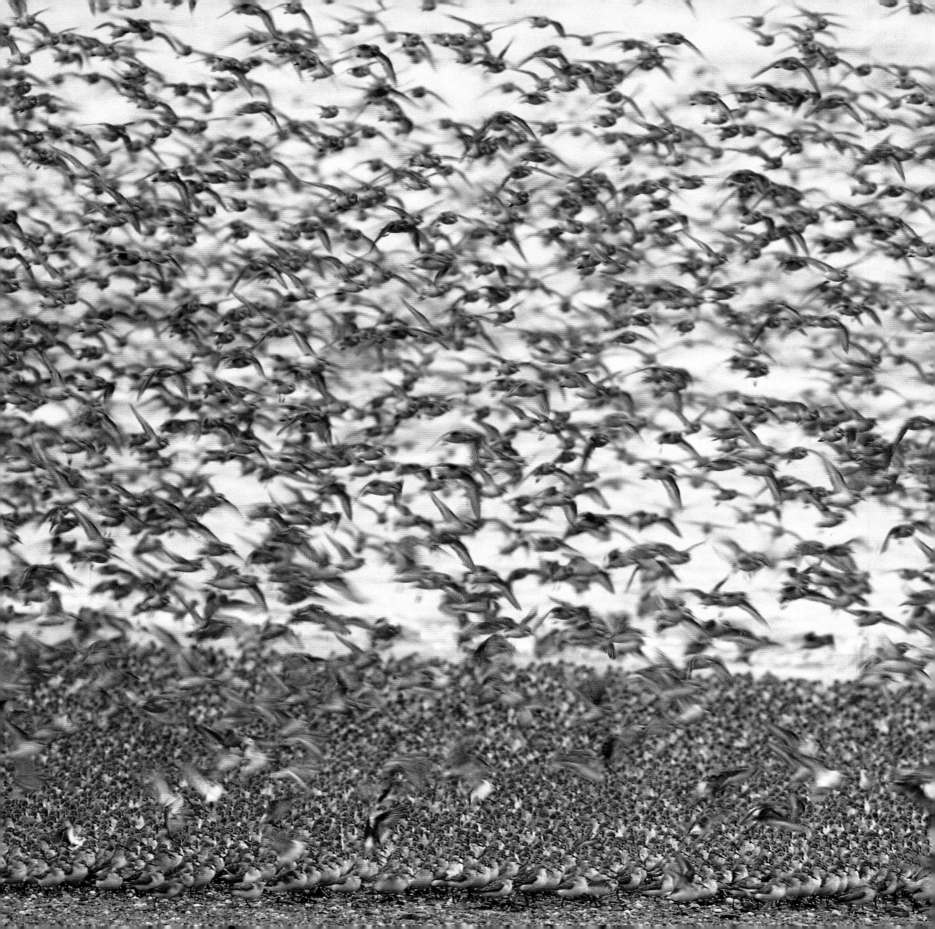

of hair or feathers thickens. Besides growing longer guard hairs, many mammals also develop a layer of thick underfur next to the skin. This dense undercoat traps heat in much the same way that our long underwear keeps us warm. Birds not only grow more feathers but also increase their insulation value by fluffing them up to trap more air. Heat is further generated by shivering, and during extremely cold bouts many birds survive by shivering continuously for days on end. While this strategy is widely used by birds, shivering is only a last desperate resort for mammals. But they, too, have an alternative method of producing heat. A special brown fat stored near the vital organs creates considerably more heat than white fat when metabolized, and is burned on demand during periods of low temperatures.

Behavior also plays a role in winter survival. Flying Squirrels, Deer Mice, and Meadow Voles huddle in small groups in sheltered sites. Not only is energy conserved by the sharing of body heat, but less heat is collectively lost because of a reduction in the total amount of the animals' exposed body surface area. Although foxes and wolves do not huddle, by curling up when resting they reduce their exposed surface area by about one third—a vital saving when energy is at a premium. Wrapping their bushy tails over their noses and eyes offers further protection.

Reduction of the body surface area with respect to the

In a den below the frostline, Woodchucks sleep away the entire winter. These large rodents enter one of the deepest states of hibernation known.

body's volume is an important principle in heat and energy conservation. A long, thin animal—a Long-tailed Weasel, for example—has a much greater surface area to volume ratio (and consequently greater relative heat loss) than a rotund animal, such as a Porcupine, even though the latter may be twice the weasel's size. The fact that Gray Wolves, Moose, and other animals with large ranges often have the largest individuals found in northern populations may therefore be an energy conservation feature. Known as Bergmann's Rule, this size increase in northern animals is by no means a steadfast rule, for more exceptions than supporting examples can be found. An increase in body insulation and a decrease in the size of ears and other extremities — major sources of heat loss — may be more important energy-conserving adaptations for some animals.

Another general trait found in northern animals is the tendency to be paler, a feature known as Gloger's Rule. Some, such as Polar Bears, winter-plumaged Rock Ptarmigan, winter-pelaged Arctic Fox, and Snowy Owls, are white. Others, including Great Horned Owls, are much paler in the northern part of their range. Although camouflage may be an issue, the paleness may actually be a vital factor in staying warm. Pigments that give animals their color are held in spaces within the hair or feathers. White hair or feathers lack pigment and thus contain empty air pockets. Just like air spaces between glass planes reduce the heat

(Opposite) Each fall a million or more Arctic-nesting Semipalmated Sandpipers gather and feed in the Bay of Fundy region. After doubling their body weight in a mere ten days of feasting on mud shrimp, these sparrow-sized shorebirds fly to Suriname, in South America, an incredible non-stop flight that lasts only three or four days.

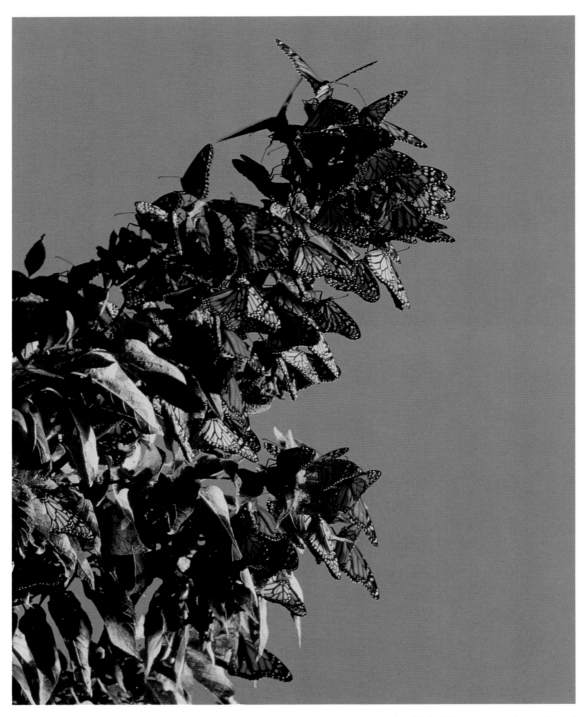

(Above) On their way to Mexico's remote mountains, Monarchs in Ontario periodically build up in numbers along the north shore of Lake Erie, roosting in trees overnight. When conditions are favorable for crossing the lake and the morning sun has warmed their tiny bodies and wings, the butterflies soon depart.

Black Bears are extremely efficient hibernators but, unlike Woodchucks, can be easily awakened from their sleep. This den among the roots of an overturned tree is fairly typical.

loss through windows, these spaces lower the thermal conductivity of the body covering. They also scatter incoming light rays, transferring some of the light energy into a heat source.

Body extremities are usually a source of excessive heat loss. When humans take part in outdoor winter activities, the feet and hands are the first to signal when it is time to go back inside to the warmth. Yet ducks, gulls, and otters are able to stand on ice or swim in freezing waters for hours without ill effect. A heat exchange system located in the extremities is responsible for this unusual feat. The sys-

tem consists of veins and arteries in such close proximity to each other that heat is transferred from the warm out-flowing arterial blood to the cold venous blood returning to the heart. This heat transfer between the opposing blood vessels actually conserves energy on two counts. Blood returning to the heart is already partially warmed, reducing the amount of energy needed to bring it to body temperature. Blood flowing out to the extremity is cooled, lowering the temperature of that body part and thereby reducing the temperature gradient between it and the adjacent environment. In turn, this reduces the

(Above) Innocuous globular swellings on Goldenrod stems identify the novel wintering sites of Goldenrod Gall Fly larvae. (Opposite) The swelling of the plant tissue not only buffers the effects of the external environment but also provides the grub with a source of food. Glycerol-aided supercooling allows the grub to survive exceedingly cold temperatures.

amount of heat lost from the extremity. This counter-current system is enhanced further by the constriction of smaller surface veins, a feature that shunts more blood through the main veins.

During sub-zero weather, especially at night, many animals conserve body heat by resting in sheltered sites. The dense foliage of spruces and other conifers, particularly when laden with snow, traps heat. Moose and deer lay under the trees, while birds roost among the branches. The snow on the ground also serves as a warming blanket for

animals, and a few birds, including Ruffed Grouse and Common Redpolls, will dive into it on a cold night. Other animals find relief in the special zone where the snow meets the ground. Here, temperatures hover just below the freezing mark, at times 45 degrees Fahrenheit (25° C) warmer than the temperature above the snow. Besides offering a warmer microclimate, this region, known as the subnivean space, also provides an easier route for mice, voles, and other small mammals to travel because of a unique ice crystal configuration created by the bottom of the snow pack.

Through a variety of physiological, physical, and behavioral adaptations, some animals manage to stay active during winter. But for every species that challenges winter's power, countless others choose to evade it. Escape is achieved in two exceedingly dissimilar yet equally remarkable ways. For many birds, as the great ecological crunch approaches, escape consists of migration to more hospitable haunts where warmth and, most importantly, food awaits. Triggered by the shortening of the amount of daylight—the photoperiod—most depart well before food resources actually disappear.

But prior to departure, preparations must be made as considerable energy is required to make the trip, which often spans thousands of miles one way. Fuel reserves in the form of fat deposits are rapidly built up as soon as the breeding season is over. Fat is stored in several places in the body: under the skin, in most muscles, and

around the wishbone, liver, and gut. The increase in weight is dramatic, with many small birds doubling their body mass. Before migrating, Blackpoll Warblers grow from about a third of an ounce (11 g) to almost three-quarters of an ounce (20 g), and Ruby-throated Hummingbirds top the scales at one-fifth of an ounce (6 g) — exactly double their summer weight. The fat reserves are used up during migration, but as the bird grows lighter, fuel efficiency actually increases. Near the end of the flight, a single ounce (28 g) of fat provides two and a half times more power than it did at the start of the trip.

Birds often migrate in large flocks. Hundreds of warblers drift through the crowns of trees, fueling up on caterpillars and other insects during a stopover. Waves of ducks cloud the dawn sky as they seek sheltered bays in which to feed and rest. Perhaps the greatest advantage to flocking during migration is safety from predators. There are more eyes present to look for danger, and, due to the numbers of birds present, if a predator strikes, the odds are improved that any one member of the group will survive the attack.

The total distance traveled during migration varies from species to species and even within a species. Many temperate songbirds spend the winter in the tropics, while most Arctic-nesting shorebirds winter on South American coastal beaches. None, however, surpass the Arctic Tern for air miles traveled — an astounding 12,500 miles (20,000 km) before the round trip is completed. As the average lifespan for these birds is about ten years, each bird will fly about 125,000 miles (200,000 km) in migration during its lifetime — particularly impressive considering that tune-ups and parts replacement are unheard of in the bird world.

Regular refueling stops are made by many long-distance migrants. Most songbirds fly several hundred miles before stopping to feed and rest. Shorebirds make few stopovers, traveling up to 2,500 miles (4,000 km) before putting down. These tremendous distances are possible because migrating birds use a number of energy-conserving aids. Tailwinds are particularly beneficial; strong headwinds will put a temporary stop to migration. Many birds fly at high altitudes where winds are often weaker. The cooler temperatures at this altitude are also important, as water evaporation is the main mechanism by which birds deal with the excessive heat produced during flight. If birds were not air-cooled, dehydration could easily be their fate. Small birds often fly at an altitude of between a half and a full mile (1 and 2 km) during

migration, while shorebirds have been known to travel as high as three and three-quarters miles (6 km).

During migration, energy can also be conserved by the way birds fly. Small birds employ an aerodynamic bounding flight. Alternate bouts of flapping and gliding with the wings closed create a roller-coaster effect. Hawks and other larger birds flap to gain altitude, then soar downwards with their wings held out. Thermals are exploited at every opportunity, and often hundreds, even thousands, of hawks can be seen riding the rising air currents at favorable locations.

Only recently have we begun to unravel the mysteries of bird navigation. While we may never fully decipher all of its intricacies, scientific studies are steadily confirming that a number of different compasses are used during migration. The Earth's magnetic field, the stars, and the sun have all been found to play a role as locational guides for certain birds. There is also speculation that landforms, the moon, infrasound (like the sound of wind over mountains), and even smell might be used by a few species. Regardless how navigation is accomplished, the feat of leaving one continent and flying partway around the world to another, only to return half a year later, is an amazing accomplishment.

Migration ranks as one of the greatest of all natural history phenomena. Besides birds, numerous mammals, from Barren-ground Caribou to Red Bats, make yearly migrations. A few insects—the Monarch Butterfly being a notable example—also travel considerable distances to reach favorable wintering areas.

As with any solution, migration has its risks and drawbacks. Fatal storms and other perilous weather conditions may be encountered during the journey. The risk of predation increases. Those with insufficient reserves or faulty navigation systems may fail to reach their destinations. And there is no guarantee that sufficient resources or favorable environments will be found at the end of the trip. When one considers the enormous distances traveled and the hazards encountered along the way, it is not surprising that over half of all migrating birds fail to return to their breeding grounds the following spring.

Not all animals escape the hardships of winter by fleeing to more hospitable regions. In fact, many more animals avoid the stresses of winter without ever leaving home. By entering a state of dormancy, vast numbers not only resolve the winter food problem but also bypass the risks associated with migration. In a deathlike state, they simply wait for this unforgiving time of year to pass, awakening only when favorable conditions bring the return of life-sustaining resources.

Although dormancy eliminates the need to find food in winter, it does not resolve the problem of freezing temperatures. Amphibians and reptiles, animals whose environment largely dictates their internal body temperatures, necessarily become dormant in cold weather. The majority cannot survive sub-zero temperatures, however, and seek shelter in sites where the temperature remains above the critical freezing point. Most snakes enter crevices in the ground, where they congregate below the frostline. These underground shelters (hibernacula) frequently hold hundreds, even thousands, of one or several species of snakes. (Incidentally, it is believed that these masses are designed to conserve water, not heat.) Many frogs, such as Bullfrogs, Green Frogs, and Leopard Frogs, and most turtles, including Painted Turtles, Stinkpots, and Blanding's Turtles, hibernate on the bottom of ponds. While at times they may burrow into the soft bottom, they will also rest on top of it.

While most of its relatives flee the freezing effects of winter by diving to the bottom of ponds and other wetlands, Wood Frogs (opposite) remain near the soil's surface. Perhaps most amazing is this species' ability to withstand the buildup of ice inside its body, even when over half its water is in this solid state.

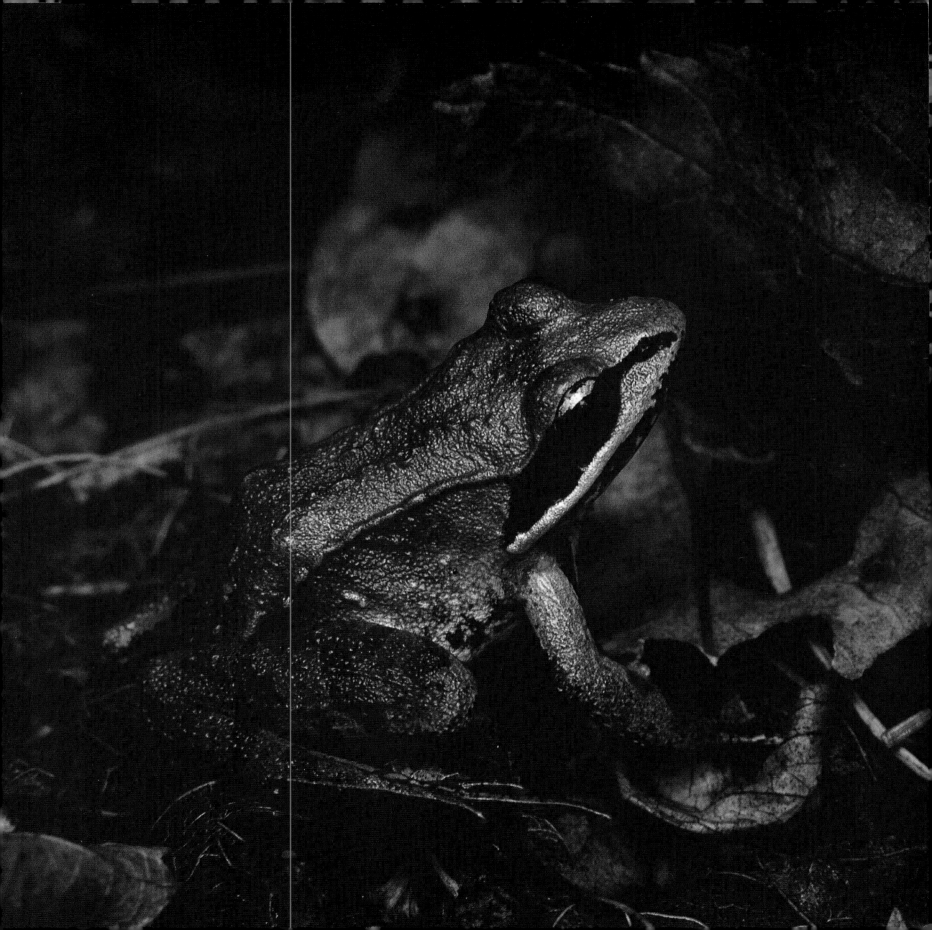

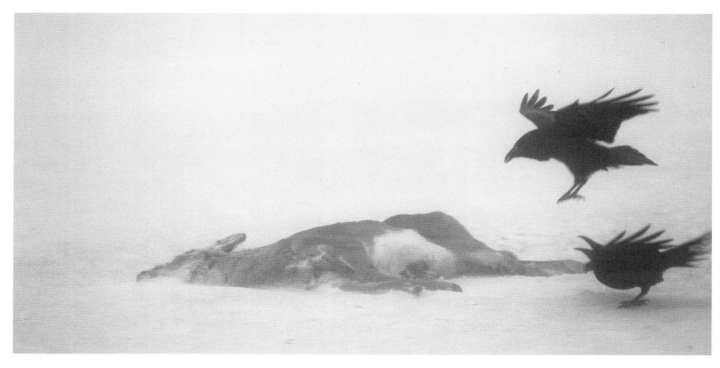

Many animals fail to survive the cumulative effects of sub-zero temperatures, food shortages, and restricted mobility that characterize winter. But in this unforgiving season, the death of one sustains the lives of many.

Although lying in the mud hides them from predators, it also restricts their access to oxygen, which is absorbed through the skin. These animals can survive in oxygen-deprived environments for a period of time, but some turtles will shift position throughout the winter to increase oxygen absorption.

Hibernating mammals do not share the same compulsion to escape sub-zero temperatures, primarily because of an ability to maintain high internal body temperatures regardless of external conditions. Nevertheless, heat loss can be conserved by hibernating in protected sites. Some animals—Woodchucks, for example—slumber away the entire winter in burrows well below the frostline. These large rodents are deep hibernators: all metabolic activity comes to a near halt; the heartbeat slows dramatically; and the body temperature hovers near 40 degrees Fahrenheit (5°C). By curling into a ball

for the great sleep, their body surface area is reduced and further energy is conserved.

While Woodchucks, Woodland Jumping Mice, and most Ground Squirrels enter a deep hibernation, Black Bears experience a very different type of dormancy. As with other hibernators, their heart rate slows down—in their case from forty beats per minute to about ten—but unlike the deep-sleeping rodents, a bear's body temperature scarcely drops at all. Black Bears also recycle their urine, retain other waste products with the aid of a special rectal plug (the tappen), and tolerate high levels of cholesterol in their blood. These extremely efficient hibernators are easily aroused from their sleep, an impossibility for any of the deep hibernators.

Chipmunks, another light sleeper, doze in their underground chambers for only several days at a time. Upon awakening, they seek out their stores of edibles and

visit another chamber to release body wastes. With both bodily needs satisfied, they again retire for another prolonged nap.

Because invertebrates, like reptiles and amphibians, are ectothermic animals, they necessarily become dormant during cold periods. But, for the most part, insects and their relatives do not need to escape winter's frozen reach. Many can survive sub-zero temperatures, even for extended periods, as long as the water inside their body cells does not turn to ice. When this water freezes, it expands, bursting cells and destroying all life functions. Any animal that spends the winter dormant and exposed to the cold must ensure that its internal structures are protected from this potentially fatal event. To do this, ectothermic animals employ one of two main strategies: some prevent internal liquids from freezing; others actually promote it.

Most winter-hardy invertebrates avoid freezing through a process called supercooling. Antifreeze, usually in the form of glycerol, is added to the body water, dramatically lowering the temperature at which lethal freezing occurs. Because ice requires a particle around which to form, supercooling insects stop feeding before the onset of cold temperatures and void their digestive tract of any material that might initiate the freezing process. Internal particles that cannot be eliminated are altered or "hidden" to avoid ice formation. By taking these precautions, the insects are usually able to withstand temperatures in the range of -20 to -50 degrees Fahrenheit (-30 to -50°C). But to provide a substantial safety margin, they seek shelter during the winter in protected sites: in the ground, under bark, in plant galls, or in cocoons.

Incredibly, some animals can actually withstand ice formation inside their bodies. But rather than have ice form within the cells—a fatal event—these freeze-tolerant animals allow ice to form only in non-vital areas between the cells. In fact, special nucleating proteins actually encourage ice formation outside the cells. Antifreeze is added inside the cells to protect their liquid integrity. Although relatively rare, even in insects, freeze-tolerance is found in several amphibians and one reptile. Rather than dive to the bottom of ponds, Gray Tree Frogs, Spring Peepers, Chorus Frogs, and Wood Frogs remain near the soil surface during winter. Even though half of their body water can be frozen, these hardy amphibians thaw and return to life each spring. Their tolerance of freezing allows them to mate very early in the year and exploit the predator-free melt ponds, which vanish by summer's end. This ability also permits them to withstand the cold spells that still punctuate their early breeding season. Hatchling Painted Turtles are the only reptile known to be freeze-tolerant during winter hibernation. After hatching in the fall, the baby turtles may remain in the nest, not migrating to water until the following spring.

Animals demonstrate remarkable ingenuity in resolving the killing temperatures and lack of resources that accompany winter. But whether an animal stays to challenge this unforgiving season or escapes it by either migrating to a more tolerable climate or waiting out the cold months in a deathlike state, serious risks are inescapable. In nature, there is never one perfect solution to any problem. Rather, every solution reflects compromise and every compromise embraces risk.

COMMON SCENTS & THE MATING GAME

CAN YOU IMAGINE A WORLD OF SILENCE, VOID OF DAWN symphonies of exquisite bird song and evening rhapsodies of Field Crickets and Katydids? Or one where butterflies lack their brilliant hues and magnificent antlers no longer adorn the heads of bull Moose? Yet, these and other natural wonders that so enrich our world would not exist if animals were not driven to reproduce. Reproduction is a highly complex function, and a great variety of intricate visual, olfactory, and auditory traits, as well as elegant behaviors, characterize this important phase of animal life. It is the raison d'être of all living things, and all adaptations for avoiding predators, attaining food, and surviving environmental stresses are just a means to this end.

By passing on its genetic material to its offspring, which will carry many of its individual characteristics, an animal achieves a certain measure of immortality. The transfer of the parent's characteristics to future generations can be facilitated in two quite dissimilar ways, each with profoundly different consequences. The cloning of a single parent results in an exact copy of the genetic material being given to the offspring. While relatively common in single-celled organisms, asexual reproduction—sometimes referred to as the Xerox method of reproduction—is rarely performed by larger creatures. Instead, most animals produce progeny through sexual reproduction, where two individuals of the same species equally contribute toward the genetic makeup of the offspring. While asexual reproduction may be a safer, more guaranteed method of producing descendants, sexual reproduction provides variation in the offspring. It is on this variation within a species that natural selection acts. As a result, genetic variation may offer greater advantages in terms of long-term evolutionary success.

Radiant colors, melodious songs, elaborate ornamentation, and elegant rituals exist because of sexual reproduction. Animals employ these devices to win favorable attention from members of the opposite sex or to intimidate rivals competing for mates. Rarely is mating performed at random, and often an animal must convince a potential partner

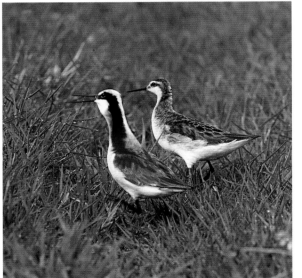

Sexual appearances and roles are reversed in Wilson's Phalaropes. In this polyandrous species, the brightly plumaged females court the quite drab males.

Sexual reproduction dominates in the animal kingdom. Here, Colorado Potato Beetles consummate their courtship.

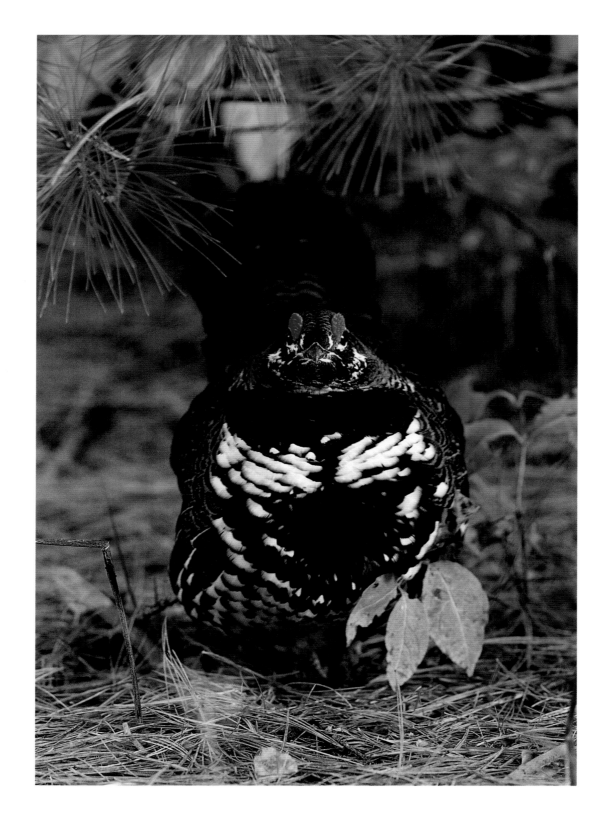

Animals frequently display conspicuous badges during courtship or territory announcement. (Opposite) Inflamed red combs over the eyes of male Spruce Grouse and (above) exposed red epaulettes of male Red-winged Blackbirds may serve as courtship advertisements to females, as warnings to rival males, or both.

that it is worthy of fathering—or in some cases mothering—the offspring. Insofar as they may reflect the owner's physical (and possibly genetic) fitness, conspicuous and exaggerated physical attributes might be interpreted as manifestations of either the animal's suitability as a mate or its superior prowess as an adversary. An undernourished, underaged, overaged, or unhealthy animal normally could not possess as impressive an endowment as a healthy animal in its sexual prime, largely because the resources necessary to produce the feature would not be available. The proliferation of characteristics that serve no other purpose than to promote an animal's chances of reproducing is due to sexual selection, a discriminating force powered largely by mate choice and aggression within a sex. Generally, but not always, female choice and aggression between males drive this selective force.

The first step in the art of successful mating is to find a suitable and willing partner. Some animals, however, never meet their consorts; they simply deposit their sex cells into the nearby environment. Clams spew their male gametes into the water, relying on the current to carry them to a distant recipient. Springtails, small insects famous for their appearance on winter snows, drop stalked packages of sperm over the ground. These packages, known as spermatophores, behave like little land mines, bursting open when brushed by a female's genitalia. For the male, this style of no-contact mating incurs little risk, but there is no guarantee the sperm will fulfill its biological purpose.

Despite never meeting their mates, many species of clams are able to double their chances of reproducing successfully. By bearing both sexes, these bottom-dwelling

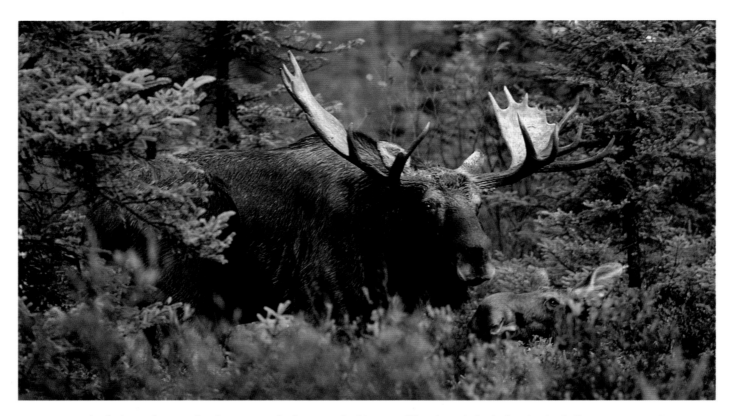

Female choice and aggression between males have resulted in a proliferation of physical traits, including ornamentation.
(Above) The antlers of bull Moose and (opposite) the huge mandibles of male Dobsonflies serve no role outside of the mating season.

animals can have their eggs fertilized by another clam as well as fertilize another's eggs themselves. Earthworms, slugs, and snails also greatly increase their reproductive potential by bearing both sexes. This strategy, called hermaphroditism, may be important for sedentary and slow-moving animals, which meet (and thereby mate) infrequently or primarily by chance.

Although some animals rely on chance encounters, most take a much more active role in the pursuit of mates. Many employ highly visual displays to advertise their availability as a mate and/or their occupation of a territory. In most cases, the male holds a territory and performs the ritual. Ruby-throated Hummingbirds, for example, swing continuously back and forth along an arced flight path, behaving like living pendulums stuck

on high speed. In contrast, male Red-winged Blackbirds slowly flutter over cattail marshes, red epaulettes blazing from their wings.

Courtship plays an important role in animal reproduction, for it allows an animal to identify another of its species readily, provides a means for mate evaluation, and allows for competition within a sex. Often courtship involves the flagrant display of some exaggerated physical trait. The massive antlers of bull Moose act as honest badges of status since only healthy bulls in their prime grow the most impressive racks. When two bulls spar or push against each other's antlers, the lesser of the two learns that the larger antlers of his opponent are a reflection of the power hidden beneath. As antler presentation precedes aggressive interaction, these lessons provide a bull

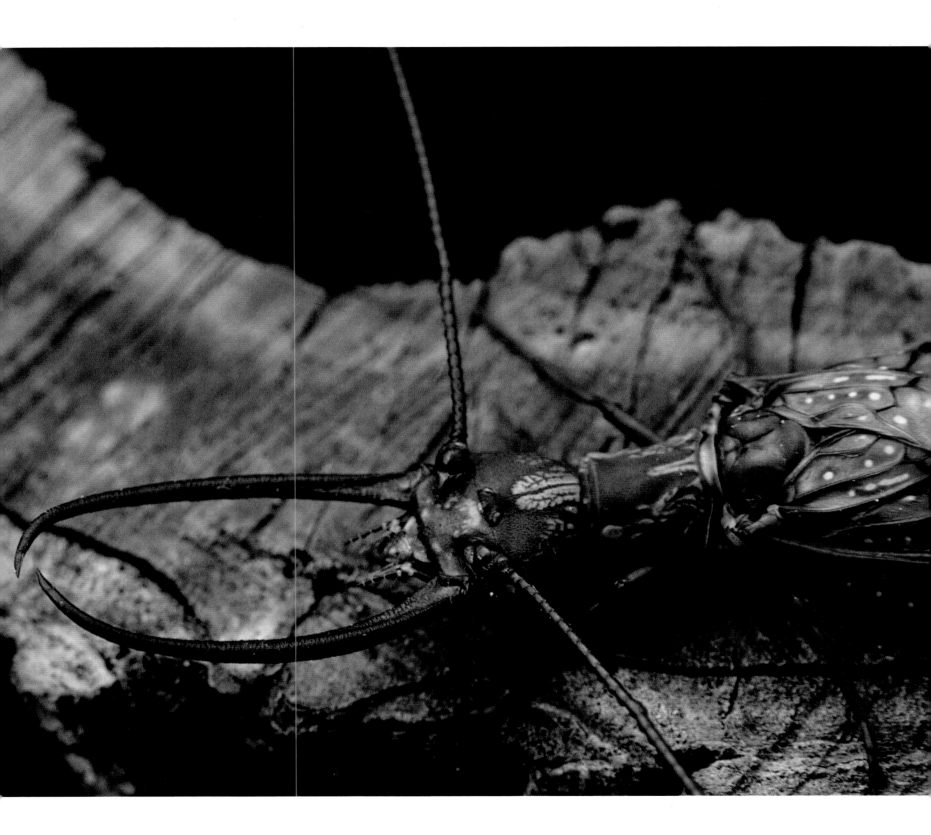

with a surefire way of evaluating an opponent and thereby foregoing any physical contest that might not end favorably. Females may also evaluate and select a mate partly on the basis of the size and shape of his ornamentation.

Exaggerated physical attributes are often designed to attract the female. Some behavioral biologists believe that male trait manifestation is due only to a female's preference for that trait and has no correlation with other qualities of the bearer. Other biologists believe that the trait reflects in some measure the bearer's worthiness as a mate. Perhaps the trait indicates a superior ability to find food. Because it is really a physical handicap, the trait might demonstrate high genetic quality, since only a superior male could possess it and survive. Or perhaps the trait simply makes the male more visible to females. Whatever the underlying principle, females do choose males on the basis of their sexual adornments. Male Barn Swallows boldly show off their long, forked tails in flight or even when sitting. The longer the tail, the greater the chance of being chosen as a mate. Studies have even shown that possession of a longer tail reflects a superior resistance to parasites, a trait that is passed on to the offspring. Thus, there is real proof that exaggerated adornments relay useful information to a potential mate and that females select males, at least partly, on the basis of these traits.

It is not always the male gender that possesses prominent sexual characteristics. Female Phalaropes are much more brightly colored than the males. This rever-

(Opposite) In most animals, such as these Mallards, males are more brightly colored or more ornately adorned because of female choice. (Above) The color of a male House Finch is a reflection of a carotenoid-rich diet during its molt. The brightest red males are preferred by females as mates, for they are proven skillful foragers and therefore will be better providers for her and her young than dull-colored males.

sal in sexual plumage also reflects a reversal in mating strategy. It is the female that competes for mates and performs courtship rituals.

While most visual displays are confined to daylight hours, one of the most intriguing courtship spectacles takes place only after the sun disappears from sight. Dots of light, vanishing as quickly as they appear, mark the courtship flights of male Fireflies. Each species of this misnamed family of beetles produces a unique flash pattern of white, green, or orange luminescence. Additionally, each type is active at a specific times of year and night or in a certain habitat, creating less confusion among the species. A female Firefly patiently scrutinizes the light show from an advantageous perch, until she spots a male that appeals to her. Then she quite literally turns on the charm by flashing back an appropriate response, thereby revealing not only her sexual interest but also her location.

As impressive as they might be, visual displays are usually effective at close ranges only. And the effort often increases the animal's risk of exposure to predators. For these reasons, many animals utilize sound for at least part of their advertising program. Sound effectively broadcasts an animal's desire across a longer distance and enables the creature to advertise from relative safety. It can also be used to announce that a territory is still occupied after mating occurs.

Birds are famous for the use of sound in courtship. Many songbirds, particularly thrushes, warblers, and finches, produce quite elaborate vocalizations, which

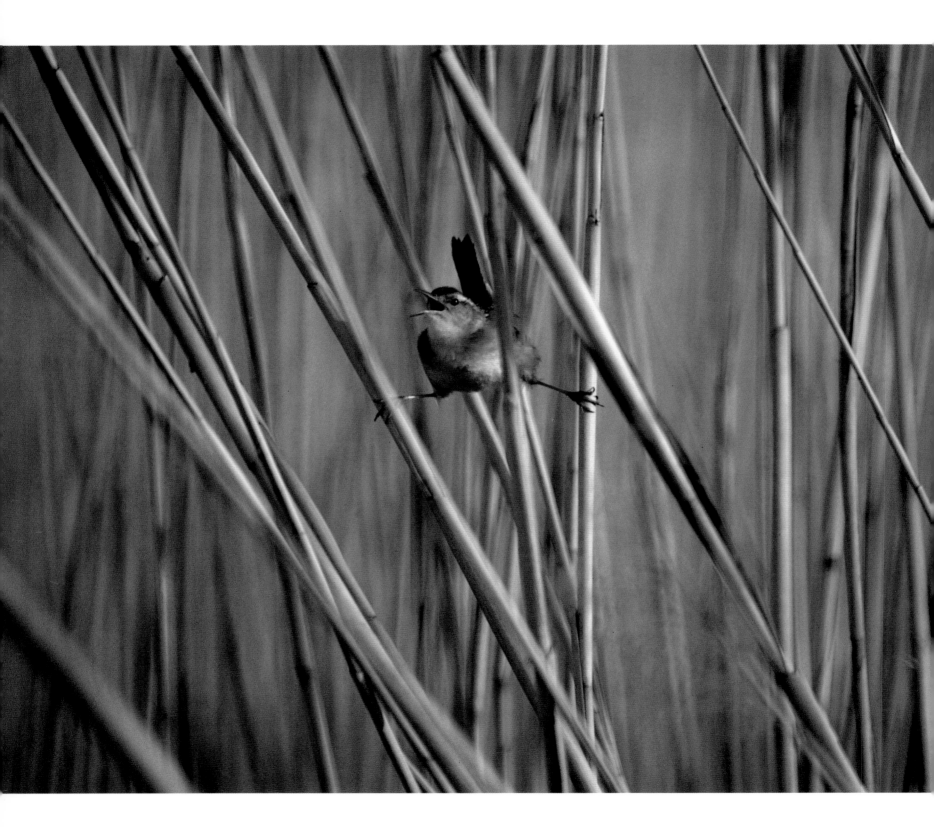

(Opposite) Mate attraction in Marsh Wrens involves song and (above) the offering of dummy nests.

convey valuable information to potential mates. Besides being a species-specific badge, through its individual quality a song may also reflect in some way the physical status of its producer. But not all bird songs can be termed musical. Owls, for example, use vocalizations for courtship and territory definition, but their low-frequency calls, while well designed for traveling through heavily wooded regions, would rarely be considered melodious, even by the most untrained ear.

Frogs are also renowned vocalists, especially in spring, when the choruses of Spring Peepers and other early singers are at times almost deafening. By closing off the nostrils and forcing air through extensible vocal sacs (single in some species, paired in others), these tiny amphibians can produce a sound expected more from animals of a much larger size. Because several species often co-inhabit the same location, the unique calls of each prevent any cases of mistaken identity.

Song variation also occurs within a species, thereby permitting individual recognition. Deeper or longer calls may reflect a larger, more fit caller, and longer periods of calling may indicate an abundance of food in a territory. But regardless of the meaning behind the sound, males call incessantly to define their territories and to attract females, which miraculously seem to be able to sort out who's who amid the tremendous din. Because a good-quality

territory may be a vital asset in attaining mating opportunities, the holder will usually vigorously defend it. Male Bullfrogs, for example, perform violent wrestling matches in their efforts to win and keep prized chunks of marsh real estate.

Many audible courtship or territorial advertisements are not produced vocally but through the use of external body parts. High above wetlands, a maniacal, laughlike whistle accompanies the aerial antics of Common Snipes. This peculiar sound, known as winnowing, is created by the vibration of the outer tail feathers. Other types of feathers can also be used to produce sound. From atop moss-covered logs, male Ruffed Grouse rapidly beat the air with their wings, permeating early spring woods with their familiar drumming sounds. Drumming of a different sort rattles from high up in the forest canopy where woodpeckers rapidly strike their beaks against dead or hollow wood. In many species, only the male drums, but the females of a few species, including Hairy Woodpeckers and Downy Woodpeckers, also perform this courtship and territorial ritual.

Insects are particularly adept at creating sounds with their bodies. Stridulation—the rubbing together of two body parts—is the preferred communication method of many grasshoppers and crickets. But within this group, the actual body part used varies considerably. Long-horned Grasshoppers and Field Crickets have a rudimentary fiddle on their front pair of wings. A filelike ridge (appropriately called the file) on the underside of one forewing is stroked by the scraper, a sharp edge along the base of the other front wing. Slant-faced Grasshoppers rub their hindlegs, bearing a ridge of short pegs, against the thickened forewings. Band-winged Grasshoppers strike their hindwings together in flight, producing a bizarre electri-clike, snapping sound.

A familiar insect song on hot summer days is the high-pitched buzz of Cicadas, commonly known as heat bugs. Males create this rather monotonous love song with

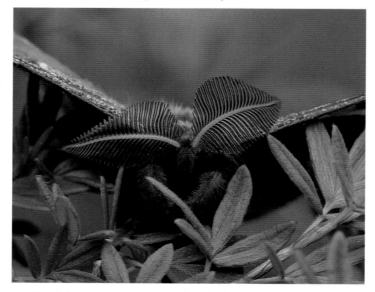

The elaborate antennae of male Polyphemus Moths are used to track the scent molecules of desiring females.

a pair of sound organs called tymbals, situated on the sides of their abdomen. Here, a series of riblike bands set in a membrane are "plucked" by muscles up to five hundred times per minute. A large, internal resonating chamber generates the characteristic loud buzz that dominates the sleepy summer heat.

While sound is widely used for long-range advertisements, sexual messages are sent over even greater distances through a more silent means. With the notable exception of birds, many animals release special scents that carry information about the producer's sexual state. Known as pheromones, these scents are often produced near the genitalia and, particularly in mammals, are released with the urine. Cow moose freely spread pheromones during the "attractive phase" of their breeding period. By assuming a facial posture (known as flemen) in which the lips are curled back and the mouth is agape, bulls enhance the ability of the vomeronasal organ in their palate to receive these stimulating chemicals. Bulls also spread their own pheromones during the rut. By rolling in shallow pits they have dug and urinated into, these massive beasts become walking billboards of scent.

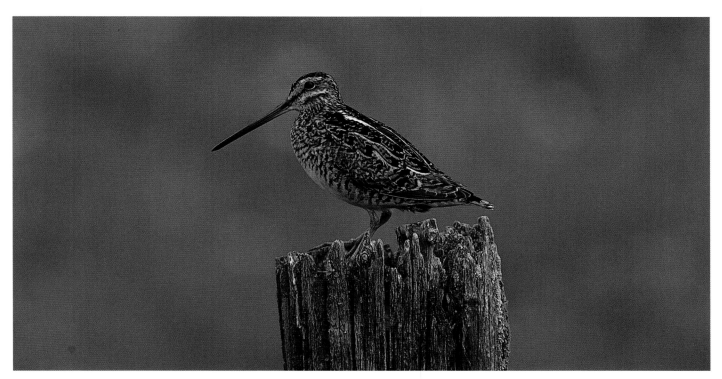

The territorial sound of the Common Snipe (top) is produced by the vibration of its stiff, outer tail feathers (bottom).

Pheromones play a vital role in the sex lives of insects, especially those active at night. The use of these sexual perfumes is highly refined in the Silk Moth family. Males of this striking group, which includes some of the world's largest and most beautiful moths, such as the Cecropia and Polyphemus, are characterized by enormous, plume-like antennae. Containing as many as four million pheromone-sensitive pores each, these massive antennae enable a male to detect and track an airborne scent trail from a desiring scent-releasing female almost two miles (3 km) away.

Snakes, salamanders, and many other groups of animals also use pheromones to entice mates. Even aquatic animals, such as female Catfish, employ these powerful attractants. But while pheromones may signal sexual maturity and readiness, they can also play a role in stimulation. Male Snowshoe Hares leap over females during courtship, showering them in pheromone-enriched urine. A potential partner of a male Porcupine also receives a liquid dowsing from up to an amazing six and a half feet (2 m) away. On the surface, these examples may look suspiciously like sexual foreplay gone awry. The spray of pheromones, however, may actually be important for stimulating ovulation.

As mate attraction rarely depends only on one sense, most animals employ a mixture of advertisements. Vocalizations often accompany visual displays, and pheromones may be used with either or both of these. With their loud, bawling calls and liberal release of pheromones, cow Moose attract bulls. In turn, bulls use vocalizations, pheromones, and the configuration of their antlers to impress cows. Naturally, the type of advertisement used depends on environmental constraints as well as the species of animal.

Courtship can also involve the offering of gifts. Male Bluegill Sunfish and Smallmouth Bass offer females nest sites that they have scooped out with their tails. A male Marsh Wren constructs several dummy nests on his territory. The number of nests built may indicate the quality of his territory or his reliability as a provider.

For some animals, the offering consists of edible food. Male Common Terns pass small fish to the females, a ritual that helps to form the pair bond and possibly to demonstrate the male's ability to provide for the chicks. As both parents take part in feeding the young, it only stands to reason that one good tern deserves another.

Courtship gifts sometimes appear to be on the unconventional side. Certain male Scorpionflies offer balls of saliva to potential mates. Full of protein, these spitballs probably provide females with a rather satisfying meal, one full of nourishment for egg production. Depending on the species of Dance Fly, the gift offered to a potential mate varies considerably in sophistication. Some species offer a silk balloon, others a captured insect, and still others an insect neatly gift-wrapped in froth or silk. But unlike human courtship gifts designed to engender passionate feelings in the recipient, the nuptial gifts of predatory animals probably serve more of a life-saving function. Because many predators are programmed to kill at every opportunity, a male may be placing himself in real danger when he approaches a female of his own species. By providing an edible gift that keeps the female occupied during mating, the male betters his chances of not becoming a meal himself. The gift may also provide an important protein boost prior to egg-laying. The males of some predatory animals that offer no gifts, such as many Orb-weaving Spiders, achieve a measure of safety by being considerably smaller than the females. But just in case a hungry female might still regard a male as a potential meal, many also pluck special nuptial songs on her web to

Pheromones released by females often attract several males. Which of these four male Net-winged Beetles actually fertilizes the eggs of the female (the large beetle on the bottom) may involve events both outside her body (physical competition between the males and her choice of mate) and within her body (stimulation and sperm competition).

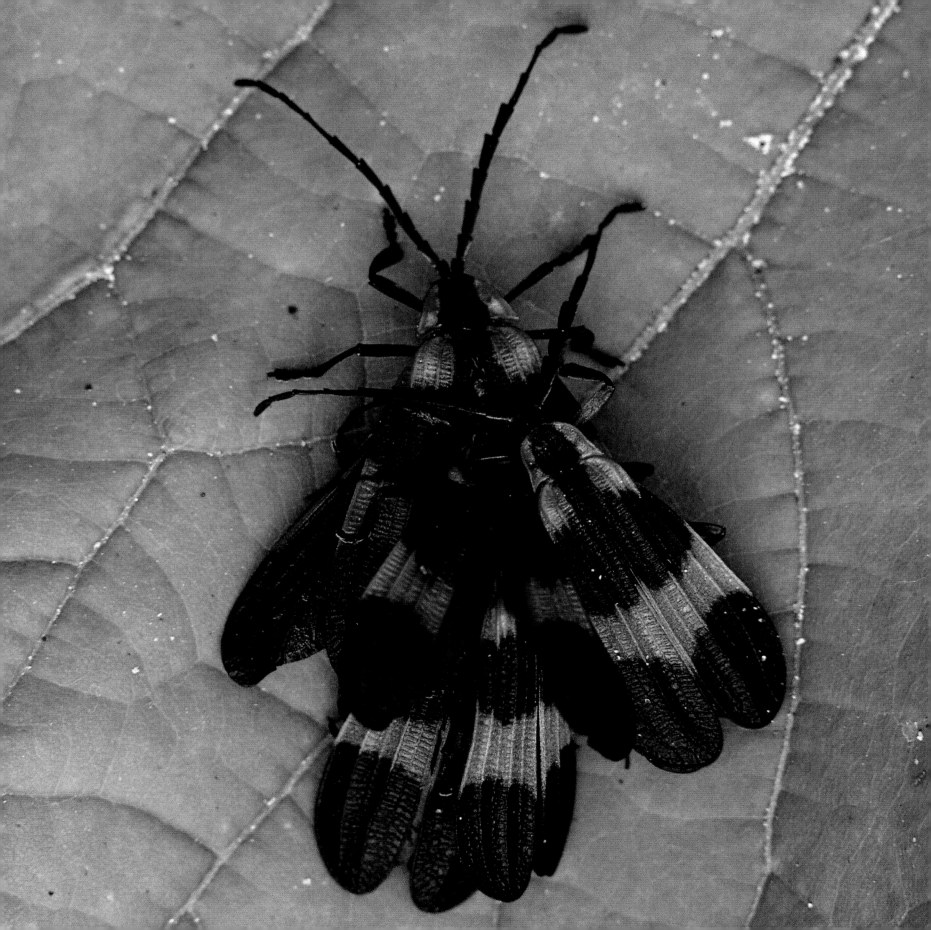

make her aware that it is a possible mate and not an edible morsel dropping in for a visit.

In addition to the danger of being consumed by a ravenous female, mating involves a number of other risks for amorous males. Advertising for mates often increases the exposure to predators. For example, displaying shorebirds become easy targets for Peregrine Falcons, Field Crickets are tracked down by parasitic flies through their songs, and hungry amphibians as well as predacious relatives are attracted to the neon show of Fireflies. The mating game also carries risks of a different nature. The time and energy put into attracting a mate might go for naught, exploited by a non-advertising cheater. While most male frogs and crickets stake a territory and call for females, there are individuals in both groups that silently lurk near the edge of a caller's domain. If an interested female approaches, looking for the singer, she may be intercepted and waylaid by one of these satellite males. Some cheaters go to astounding lengths to conserve energy and avoid the risks associated with honest advertising. When a male Scorpionfly presents a courtship gift to an apparent female, not always does he receive his just desserts for his efforts. On occasion, the "she" turns out to be a "he," who quickly grabs the gift and flees.

Mating can be a dangerous act for one or both partners. Female spiders, such as this Black and Yellow Argiope, could easily mistake a male for a meal. To avoid being consumed by more than love, the considerably smaller males may pluck an identifying tune on a female's web or, in some species, offer her a gift of food.

Having abandoned his female persona, the imposter uses the stolen prize to win the approval of some bona fide femme.

Bluegill Sunfish demonstrate incredible sophistication in their exploitation of breeding opportunities. An adult male exhibits one of three possible appearances and behaviors. Some males are large, sport bright colors, and create nests to entice females. Other adult males, known as "sneakers," lack the bright coloration and are only about one-third the size of a nest-builder. Resembling immature males that pose no threat to a breeding-aged male, these sneakers dart into a nest when mating is occurring, shoot their sperm over the eggs released by the female, and make a quick getaway before the territorial male gets wise. Another form of cheating male resembles a female and even emulates female behavior. When a real female enters the nest, the imposter slowly sinks down between the courting pair, spewing its sperm over the female's eggs. Meanwhile, the confused territorial male continues his courtship, perhaps thinking that he is having a doubly good day! The fact that all three breeding strategies exist in Bluegill populations is proof that each has its own measure of success. Again, nature shows us that a diversity of solutions can be applied to

any single life problem, including the transfer of genetic material within a species.

Once an animal encounters a responsive mate and all courtship formalities are dispensed with, the act of mating proceeds. For males, however, copulation is never a guarantee of parentage. Certain dragonflies are able to scoop another's sperm from a female's receptacle, replacing it with their own. To defend against this, males of a number of species remain coupled with the female until the eggs are fertilized and laid.

Males may go to even greater lengths to ensure that their mating act is the final one. Many seal off access to the female's reproductive opening with some form of plug. Featherwing Beetles produce giant sperm twice their body length that, with the aid of gripping spines, prohibit other sperm from entering. In addition to regular sperm, a number of beetles produce copious amounts of headless sperm. These jam the female receptacle, creating a physical barrier to any other sperm that may appear on the scene later.

Often the mating or copulatory plug consists of a special secretion that forms a tight-fitting wedge. Moles create a plug from a mixture of secretions released by their Cowper's and prostate glands. In some cases, the plug discourages the efforts of other males in more than just a physical way. The seal-forming kidney secretions of Garter Snakes also contain an anti-aphrodisiac that makes the female far less sexually attractive to other males. Anti-aphrodisiacs may even function as a mating plug; matrone, a chemical secreted by certain male mosquitoes, increases female receptiveness at the moment of mating but decreases the responsiveness of future male callers.

At times, mating plug production can be rather dramatic. Male Black Widow Spiders insert sperm with the use of a specialized mouthpart, the palp. Once inside the female, the palp detaches, remaining held tightly in place by its numerous spines. Other animals sacrifice more than just an appendage in their attempt to block further access to the female. For a male Biting Midge (alias a No-see-um) mating is his final act: during copulation, the female impales his head with her piercing mouthparts; as he injects his sperm into her, she literally sucks the life out of him. His lifeless body remains coupled to hers for a time, however, effectively sealing off her sexual opening and ensuring that, genetically speaking, his sacrifice was not in vain. Perhaps most spectacular of all is the copulatory plug formed by male Honeybees. You might say that sex for the drone bee is a "real blast," for upon mating with a queen, his genitalia explode from his body. The rich endowment of spines and flanges guarantees that the genitalia remain firmly embedded in the queen, denying access to future suitors.

These rather drastic efforts underline the importance of ensuring that the mating act results in the transfer of genetic material. But even these attempts fail. Queen Honeybees have been found carrying the genitalia of several males. Despite their physical design, copulatory plugs are no guarantee that another male will not deliver the successful sperm. Some animals, including Ground Squirrels, have been known to dislodge the plugs by using their penis bone (the baculum) to pry them out.

Reproduction is an essential part of every animal's life. Despite all the risks associated with mate attraction and mating, sexual reproduction offers animals more than just an opportunity to transfer their genetic material to the next generation. The genetic line of a species can potentially carry on almost indefinitely if future generations continue to flourish and pass on the superior traits to their progeny. Because such high stakes are on the table, many animals make efforts to enhance the survival of their young—so that in time they, too, may play the mating game.

FUTURE INVESTMENTS

WITH ALL ITS COMPLEXITIES, MATING OFTEN REQUIRES A considerable investment in time and energy. Long after the reproductive act is completed, however, many animals continue to devote time and resources into caring for their eggs or young. By maximizing the chances that an offspring will survive to a self-sufficient stage, animals are also improving the odds that their genes will be carried through future populations. But efforts to achieve this return are never without some cost. The provision of care increases a parent's exposure to predators or accidents, places extra demands on its internal resources, and ultimately lowers its chances of producing more young. Once again, nature demonstrates that any attempt to increase an animal's success necessarily entails some form of tradeoff.

The amount of parental care in the animal world varies tremendously among groups, related species, and even between the sexes of a single species. Longevity, fecundity, risk of predation, the availability of resources, and cost to future reproductive opportunities are some of the factors influencing the amount and type of care, as well as determining which parent provides it. An extremely complex subject, parental investment in offspring is currently the focus of much academic study and debate.

Parental care can be initiated at many different developmental phases. Some animals prepare special brooding sites before laying eggs; others keep the developing offspring inside their bodies, nourishing and protecting them until they develop more fully. For still others, care continues long after the eggs or young are released from the body.

But not all animals demonstrate elaborate parental care. For the majority of ectotherms, including most insects and many amphibians and reptiles, releasing the eggs into an appropriate environment is all the investment given. Bullfrogs and Leopard Frogs abandon their eggs and any further responsibility after depositing the massive cluster in a suitable pond or other wetland. Early-breeding amphibians, such as Yellow-spotted Salamanders, Wood Frogs,

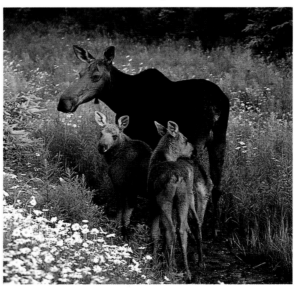

By enhancing the chances that their young will survive to reproduce, Moose and other animals improve the odds that their genes will survive into future generations.

Nursery Web Spiders protect their eggs by carrying the massive egg sac in their jaws.

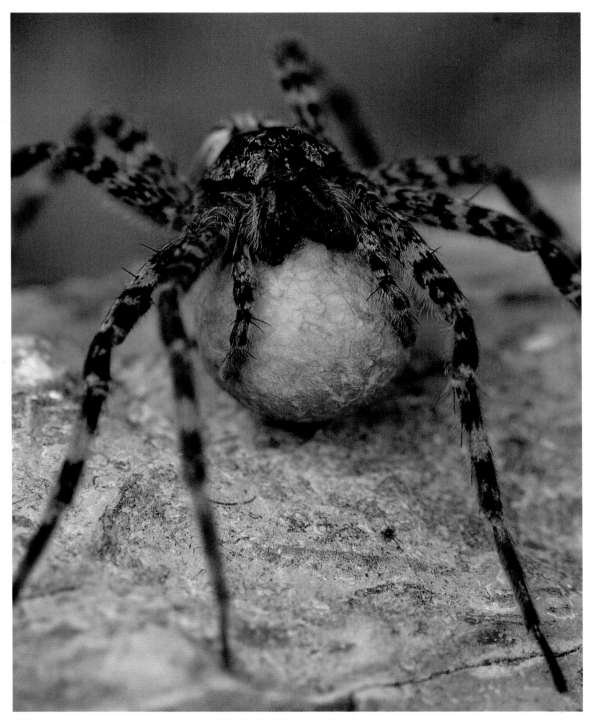

and Spring Peepers, often release their eggs in spring pools, which vanish by summer's end. Although the eggs, and later the larvae, are not guarded by the adults, a certain degree of safety is offered to them, for these temporary wetlands are relatively predator-free.

A number of reptiles leave their eggs unattended but hidden. Rotting logs are ideal egg-laying sites for many snakes, including Smooth Greens and Ringnecks. Female turtles may spend many hours looking for a suitable nest-digging location on land that borders a waterway. The nest, which may take more than an hour to dig, serves as much more than a hiding spot for the eggs. Besides keeping them out of sight, the soil incubates the eggs. Incredibly, for some species, the soil even dictates the sex of the hatchlings. Snapping Turtle eggs yield only females when the soil-incubating temperature is either 68 degrees Fahrenheit (20° C) or between 84 and 88 degrees Fahrenheit (29–31° C). Only males are produced when the temperature falls between 73 and 75 degrees Fahrenheit (23–24° C). Both sexes appear when temperatures are otherwise.

While parental care in Snapping Turtles and many other reptiles and amphibians may seem limited to locating or preparing a proper site, additional investment is usually contributed by the females prior to egg-laying. The eggs often contain a copious amount of yolk, far more than the amount needed to sustain the developing embryo. Besides providing a first meal for the hatchling, the excess yolk may help to sustain it until the hatchling is able to feed on its own. The additional reserves may also be crucial during adverse environmental conditions.

Butterflies, moths, grasshoppers, and other herbivo-rous insects abandon their eggs as well, but only after depositing them on an appropriate larval food plant. For some insects, the food source is another living animal. Tachinid Flies, Braconid Wasps, and Ichneumon Wasps seek out caterpillars and insects, leaving with them a load of living time-bombs stuck to their bodies. Upon hatching, the parasitoid intruders show their appreciation for the involuntary host by devouring the very life from it. Regardless of whether its eggs are laid on animals or plants, an egg-laying insect must invest time and energy into locating an appropriate food source for its offspring.

Some animals provide a source of food as well as a safe site in which the young can eat and develop. Many Spider, Thread-waisted, and Sand Wasps dig a burrow into the ground, then go hunting for a quarry, often another insect or a spider. They quickly paralyze the ill-fated animal and haul it back to the burrow, where they drag the immobilized prize underground and deposit their eggs on it. After sealing off the entrance, the wasp departs—usually not returning—leaving behind a living meal entombed for its soon-to-hatch young. While most digger wasps lay their eggs only after capturing a food item, some species lay first and seek their prey later. A few species even periodically provide fresh food for the young as they develop. And a number of species exploit the efforts of others. Certain Thread-waisted Wasps, for example, sneak through the grass and shrubs, carefully following a successful hunter back to its burrow. Once the digger has sealed her chamber and left, the prowler springs into action. Tearing open the seal, it enters the cavern and locates the paralyzed prey. Quickly, it replaces the owner's eggs with its own and reseals the tomb on its way out.

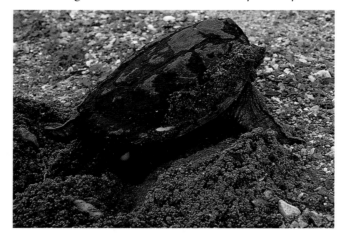

After selecting an appropriate site and excavating a nest, the only additional parental investment made by Snapping Turtles is to lay and cover the eggs.

Female Wolf Spiders, including this Burrowing Wolf Spider, carry the egg sac under their abdomen, then the baby spiders on their bodies after the eggs hatch.

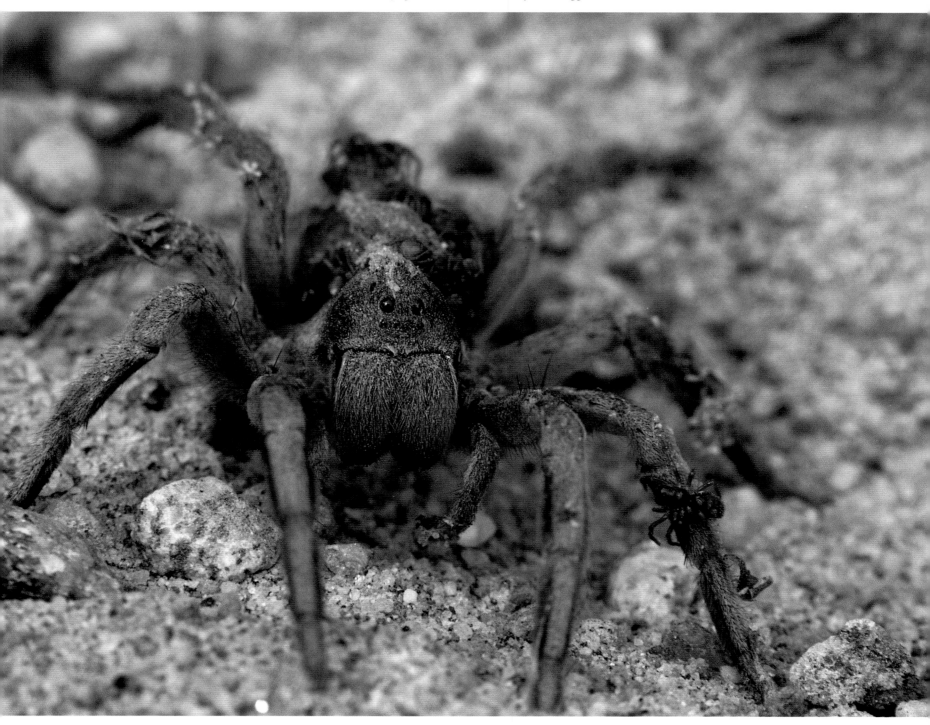

FUTURE INVESTMENTS

The eggs of precocial birds, such as these of a Killdeer, are proportionately larger than those of altricial birds, for they contain a greater amount of yolk. This sustains the embryo until it reaches an advanced stage of development.

Most ectotherms offer little parental care to the eggs and young. Perhaps they cannot effectively defend against larger predators (and might easily become a meal in the process). Or perhaps some other cost-related factor is involved. Whatever the reason, their best strategy may be to lay large numbers of eggs in an appropriate environment.

On the other hand, egg defense is an important part of parental investment for some ectotherms. Female Five-lined Skinks and Four-toed Salamanders stay with their eggs until they hatch. Female Wolf Spiders lug around a bulky egg sac firmly held in place by the spinnerets under their abdomen. After hatching, the young continue to get a free ride by climbing onto their mother's back. Nursery Web Spiders also cart around a massive egg sac, held in front by their powerful jawlike chelicerae. True to its name, a Nursery Web Spider builds a silken nursery around the sac when hatching time approaches. She remains on guard near this special web until the young disperse.

(Opposite) Parental care in Eastern Kingbirds consists of building a nest, incubating and protecting the eggs, and then feeding and protecting the young until they can fly. The brightly colored gapes help to direct the parents' feeding efforts.

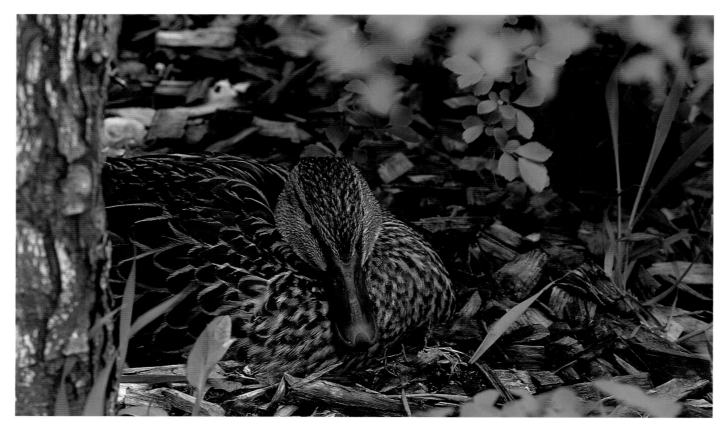

Ducks, such as this female Mallard, spend much more time incubating eggs than songbirds do, but their young leave the nest immediately after hatching and require little care apart from protection.

Eggs are not always protected solely outside of an animal's body. Through a process called ovoviviparity, female Garter Snakes and Water Snakes retain their eggs internally until they hatch, then give "live birth." This may be particularly beneficial to animals in colder climates as the eggs can be maintained at a higher temperature, thereby shortening the hatching time.

The female is not always the parent that provides care for the eggs. In fact, male care is the rule, not the exception, for fish. The males of Three-spined Sticklebacks, Smallmouth Bass, Bluegill Sunfish, and a number of other species watch over the nest, even fanning the eggs with their fins to ensure they get sufficient oxygen. Some, such as the Bowfin, continue to guard the young after they

hatch. And a few males even play a somewhat maternal role by protecting the eggs inside their bodies. Many male Pipefish and Sea Horses, for example, hold the eggs in special brooding pouches until they hatch. A few species also possess the amazing ability to deliver nutrition to the developing embryos through a male placental connection!

Occasionally, males play a somewhat less voluntary role in egg care. The females of several species of Giant Water Bugs glue their eggs directly onto a male's back. Besides securing the eggs, the adhesive also renders the male flightless, making it impossible for him to shirk his parental responsibilities.

The care of eggs and young is perhaps best exemplified in birds. With only a few notable exceptions, virtually

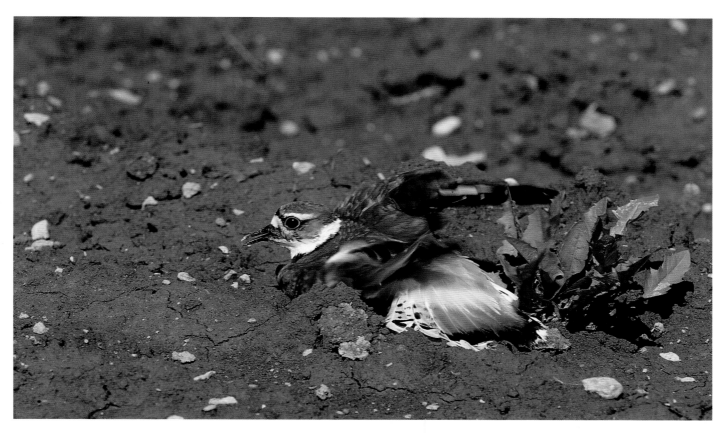

Nest defense of Killdeers involves a most convincing broken-wing act complete with a conspicuous "bloody" rump and inner tail. The intensity of this act peaks just before the eggs hatch.

all 9,000-plus species demonstrate at least some measure of parental care after the egg leaves the body. But there are striking differences between species in the type of care provided in the time from when the egg is laid to when the young are able to fend for themselves.

Songbirds generally lay a clutch of rather small eggs in a well-structured nest. A major investment of energy can go into nest construction—sometimes more than a thousand material-gathering trips are involved. While the outer walls often contain local materials to help camouflage the structure, the inner area is usually lined with fine or soft materials, such as grasses, leaves, moss, or the down of plants. Mud, caterpillar silk, spider webs, and even saliva are used as adhesives to hold the entire structure together. Cave

Swiftlets produce nests composed solely of salival glue. Perhaps a more appropriate name for the famous delicacy produced from these nests would be bird spit soup!

Although most nests are used only once, for a period of three to four weeks, these labor-intensive structures are worth the effort. Nests cushion the eggs and young, and insulate them from cold, heat, wind, and rain. Besides holding the clutch together and preventing the young from falling out, nests also hide the contents, including the incubating parent, from predators. While the eggs of most songbirds hatch in about two weeks, the young (called nestlings) are totally helpless and require extensive care. Due to this highly altricial state, they remain in the nest for almost the same length of time as it took the eggs to hatch.

Ducks, shorebirds, and grouse employ a much different nesting strategy. Most, in fact, fail to make much of a nest at all, often laying directly on the ground in a small scrape. The eggs, usually well camouflaged, are proportionately much larger than those of songbirds because they hold larger amounts of yolk. The extra food allows for a longer developmental period inside the egg, thereby enabling the young to hatch in a very advanced state. Almost immediately after hatching, the precocial young —commonly known as chicks—leave the nest and are able to feed on their own. The incubation period of precocial birds often spans three to four weeks, twice that of altricial birds. Initially, it might appear that this strategy involves more investment at the nesting stage than the altricial strategy. Such is not the case: altricial birds spend an equivalent amount of time between incubating the eggs and feeding the nestlings before they fledge.

Another interesting difference between these two strategies lies in the way the parents defend the nest contents. American Robins and other altricial birds do so only halfheartedly during the egg stage. But when the young hatch, the defense antics increase in intensity, bordering on the frantic as fledging nears. Killdeers and other precocial birds employ the opposite strategy, decreasing the intensity of their defense actions once the eggs hatch. The peak of their defense occurs just prior to egg-hatching.

Why this great difference? The answer lies in the amount of investment at risk in each nesting strategy. If a clutch of eggs is gobbled down by a predator, a songbird such as an American Robin usually has sufficient time left to lay a replacement set of eggs and successfully rear a brood. Also, at the egg stage the investment in brood production is not that great. But as time passes and young are present in the nest, the parents have sunk considerably more time and resources into rearing the brood and there may not be enough time to start anew.

For precocial birds, it makes sense that more investment goes into the eggs, both in terms of yolk production and incubation time. Once hatched, the young are mobile, can usually feed themselves, and are able to evade predation to some degree. Thus, a precocial bird is much more vulnerable if a predator threatens at the egg stage. Parental defense peaks toward the end of the lengthy incubation period as the amount of investment increases and the potential for re-nesting diminishes. Because nest defense puts the parents at some risk, it makes biological sense that a bird would be willing to risk the most danger to itself only when the potential reproductive return is the greatest.

Whether a bird produces precocial or altricial young (or some hybrid of the two strategies), its eggs receive considerable care. Direct contact with the parent's body provides a proper incubation environment. Heat is transferred through a special area of the breast where the skin is void of feathers, wrinkled and flaccid, and permeated with blood vessels. This brood or incubation patch may be present on both parents if they take part in incubation—as do most songbirds—or only on one—as in most female ducks. In the case of most monogamous birds, both sexes take turns performing this task. However, for a number of birds that practice polygamy, often one sex takes care of the eggs. Red-winged Blackbirds are polygynous breeders, with one male usually having several mates. While the male defends the territory, the females perform incubation. But the roles are reversed for Spotted Sandpipers. In this polyandrous species, the female performs guard duty while her males incubate the eggs.

After hatching, precocial chicks are usually attended by only the female, except for polyandrous shorebirds in which the males usually stay with the relatively independent young. Altricial nestlings, however, require considerable more attention, and in most cases both parents provide food, shelter, and defense until they fledge.

(Opposite) Great Blue Herons rear their young on platform nests, which are often built in dead snags standing in the safety of a pond.

Extensive parental care is an avian trademark. However, a few bird species provide absolutely no care at the egg or nestling stages. Known as brood parasites, these species exploit the efforts of other birds that do devote time and energy to these tasks. Female Brown-headed Cowbirds lay their eggs in many other species' nests, carefully sneaking in when the nest is unguarded. All responsibility for the egg is relinquished after it is deposited among those already present. The returning parent may recognize the Cowbird egg as foreign and respond by removing it, abandoning the nest, or rebuilding over top and laying a new clutch of eggs. But in most cases the egg gets accepted, and the young Cowbird is raised to maturity, usually at the expense of the other nestlings. Amazingly, despite being raised by an unrelated species with a much different song and behavior, a Cowbird still retains its species identity and seeks out its own kind for mating.

As obligate brood parasites, Brown-headed Cowbirds have no other option for egg-laying. Other brood parasites, however, are not quite so restricted in their choices. Yellow-billed Cuckoos, Black-billed Cuckoos, Wood Ducks, Common Mergansers, and many other cavity-nesting ducks will drop eggs into a neighbor's nest on occasion,

Short-eared Owls have staggered hatching times. This results in a range of chick sizes, which may be an adaptation related to food supply. If food is plentiful, all might survive; if food is scarce, the older and larger chicks will survive at the expense of the younger ones, even consuming their siblings during times of severe stress.

but they also incubate a full clutch themselves. Unlike Brown-headed Cowbirds, which use a wide variety of hosts, facultative brood parasites tend to deposit eggs in the nests of their own species.

Dropping off eggs in another's nest is not the only way parental care is exploited by birds. Common Mergansers often leave their young with another mother and her brood. It is not unusual for late summer canoeists to encounter a sole female with young from several different broods (identified by their obvious differences in size) in tow. While this behavior, known as creching, is relatively unexplained (as are many aspects of parental care), it may be that a mother accepts additional young as a form of protection for her own brood. The simple increase in numbers may improve the odds that each of her descendants will survive a predator attack. But the impetus for a female to discard her young is a real mystery. Perhaps her young also benefit from the "safety in numbers" scenario, or perhaps the action is designed to enable a female in poor condition to escape the feeding competition that her youngsters provide.

In birds, parental care by both parents dominates. Not so for mammals. In the mere five percent of mammal species where males participate in the care of offspring,

(Opposite) The scarcity of suitable nesting sites is perhaps the primary reason for seabirds—Northern Gannets, for example—to nest in huge colonies. A lack of predators, safety in numbers, and the transfer of information concerning good feeding sites may also play a role.

none has the male as sole care provider. Carnivores are one of the few groups of mammals in which biparental care is relatively common, possibly because larger litter sizes and more elusive food may demand the involvement of two parents in rearing young.

Female mammals invest heavily in the production of young even before they are born. After a fertilized egg implants in her uterus wall, a lifeline supplies the developing embryo with nutrients and antibodies. Here, in the warm, comfortable environment of its mother's womb, the young grows in safety, far removed from the harsh realities of the outside world.

Not all mammals initially feed their young through a placental connection. Virginia Opossums lack a true placenta and, after a mere two-week gestation, give birth to maggotlike young lacking hind limbs and tails and measuring only half an inch (12 mm) in length. These unusual marsupials compensate for the premature birth quite nicely, though, by having the tiny youngsters lock onto nipples hidden inside a furlined pouch, the marsupium. For two months the nipples act as external umbilical chords, delivering vital nutrition to the highly altricial young until they reach a more mature state.

Unique to mammals, the production of milk provides a major advantage by enabling newborns to acquire nutrition while receiving full parental protection and avoiding all risks associated with looking for food. Lactation also reduces competition between the adult and offspring for the same food resources.

Once weaned, the young must be able to find sufficient food to maintain their growth and be mature enough to escape predators and withstand environmental stresses, such as winter. Therefore, the timing of birth is critical. Equally important is the timing of breeding, and the time period available for this activity is also tightly controlled by environmental factors. In order to perform both functions at optimal times, all mammals face a great balancing act. Ungulates, such as White-tailed Deer and Moose, breed in the fall. Their gestation period carries through the winter, but its most cumbersome stage occurs only at the very end of that trying season. Birth takes place in spring, allowing the weaned young to take advantage of the bounty of summer and develop sufficiently to survive their first winter.

Smaller animals have much shorter gestation periods and cannot juggle their reproductive phases quite so perfectly. But once again, nature demonstrates great resourcefulness and has responded with a couple of ingenious solutions. Fishers breed in late spring and give birth the following spring, eleven months later. The true gestation period, however, lasts for only two months; for the first nine months, the fertilized egg (in the blastocyst stage) floats in a state of suspended animation in the uterus. Attachment to the uterus wall only occurs at the appropriate time for gestation to commence.

Delayed implantation is found mainly in carnivores, some seals, and a handful of other mammals. Little Brown Bats are able to stretch out the time between breeding and giving birth in quite a different way. Mating is performed in August and birth takes place in early summer, but actual fertilization only occurs when the females emerge from hibernation in the spring. By keeping the sperm in storage over winter, Little Browns and a few other species of bats have resolved the critical dilemma.

Some mammals continue parental care well past the weaning stage. Gray Wolves provide food for their pups until they are about six months old. A cow Moose and her calves stay together for one full year. Cub Black Bears

Red Foxes demonstrate much more parental care than most mammals. (Opposite above) For the first month or so, the male delivers food (here, a Snowshoe Hare) to the den. (Opposite below) Once the young begin to appear from the den's confines, their milk diet is gradually supplemented with solid food brought by both parents.

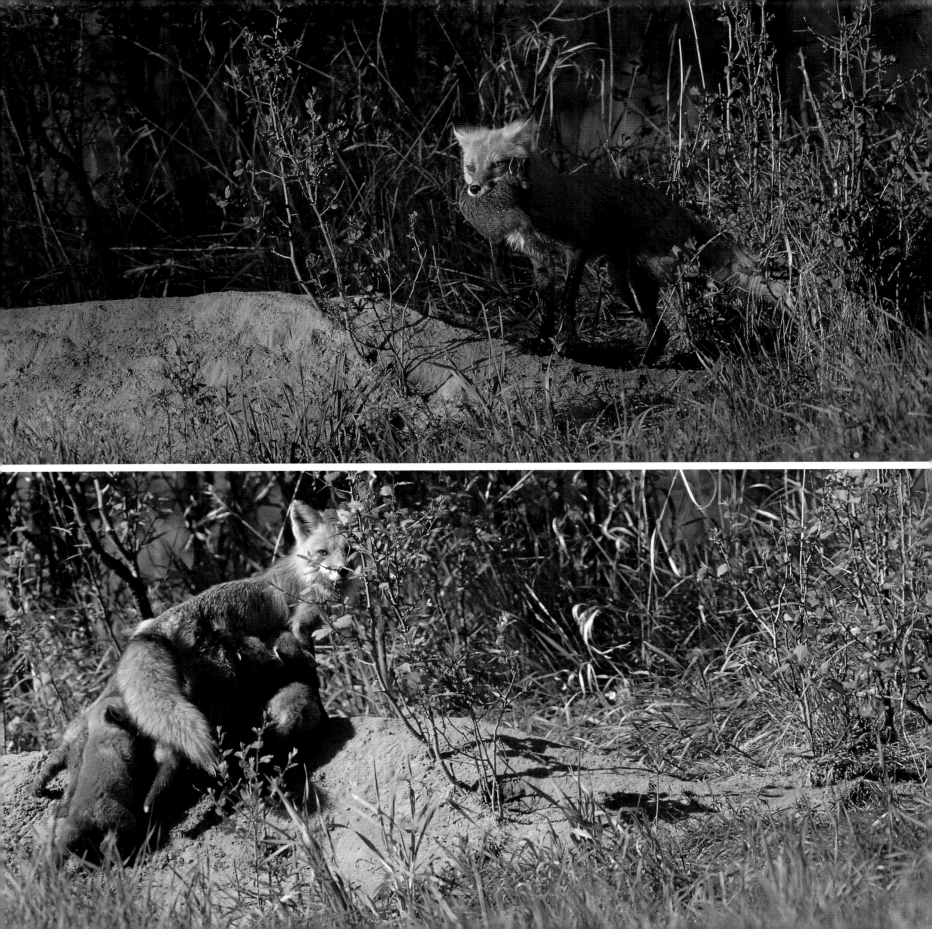

(Above) Prothonotary Warblers and other cavity-nesting birds may be twice as successful in producing young as birds that build cup nests. But the demand for cavities is high, and their availability is a limiting factor in many animal populations.
(Opposite) Parental care is a complex subject, with involvement varying greatly from species to species.

remain with their sow for two years. In general, extended care is provided by animals that have relatively long lifespans and produce few offspring.

Although mammals and birds characteristically provide advanced parental care to their young, they are not the only animals to do so. A pair of Burying Beetles not only skins and buries a mouse for their offspring to eat, but in some species even remains with the carcass and feeds the young. In social insects such as Honeybees, Paper Wasps, Ants, and Termites, entire castes care for newly hatched colony members.

The expenditure of time, energy, and resources into the care of young is a widespread phenomenon. While the amount and type of care may vary among species, the manifestation of parental care in practically all animal groups underlines the important role it plays. But the investment that parents place in their offspring represents more than just a short-term struggle for survival. It reflects the underlying fight of all living things to achieve genetic immortality.

GLOSSARY

Adaptation: Any structural or behavioral feature that in some fashion directly or indirectly improves the chances of an animal passing on its genes to future generations. An adaptation may aid an animal in any of its basic life functions (defense, feeding, mating, care of young).

Altricial: Born in a poorly developed and defenseless state.

Analogous: Performing the same general function but arising from a different part of the body.

Aggressive Mimicry: Where a predator deceives prey, often by using part of its body as a lure.

Aposematic Coloration: Bright colors or bold patterns that advertise an animal's toxicity or some other unpleasant attribute.

Asexual Reproduction: Reproduction without the union of male and female gametes. The offspring are exact genetic copies of the parent.

Autotomy: The ability to lose a body part easily without serious consequence.

Baculum: A penis bone found in certain mammals.

Batesian Mimicry: A defensive strategy in which a common harmful model is copied in appearance or behavior by a harmless and much less common mimic.

Bergmann's Rule: The generalization (to which there are many exceptions) that animals are larger in northern regions for energy-conservation reasons.

Blastocyst: A hollow sphere of cells in early embryonic development.

Brood Parasite: An animal that exploits another animal's parental care for the rearing of its young.

Caecum (pl. caeca): A saclike extension of an animal gut, often harboring microbes for digestive purposes.

Camouflage: Coloration or patterning that matches the animal's background.

Canines: Conical teeth often used in capturing or killing prey.

Carnassials: Specialized cheek teeth in Carnivores, used for shearing muscle, tendon, and bone.

Chick: The young of precocial birds.

Cones: Retinal sensory cells important for visual acuity and color discrimination.

Coprophagy: Eating animal excrement.

Copulatory Plug: A physical plug or barrier produced by a male that generally prevents other males from copulating with the female. Also known as a mating plug.

Countershading: A defense strategy in which the upper body casts shade on the paler underside, thereby reducing contrast and giving the animal a flatter appearance.

Cryptic Behavior: Motionless behavior.

Cryptic Coloration: Same as camouflage.

Definitive Host: The host in which an endoparasite reproduces.

Delayed Implantation: The delaying of the implantation of a fertilized egg in the uterus wall until an advantageous time for birth is accommodated.

Detritus: Litter formed from fragments of dead material.

Detritivore: An animal that feeds on detritus.

Diastema: The gap that appears between the incisors and the cheek teeth in many herbivores.

Disruptive Coloration or Pattern: Markings that tend to break up an animal's outline.

Distraction Pattern: A bold pattern that serves to startle a predator or deflect its attack to a non-vital body part. Also known as a startle pattern.

Dormancy: A state of rest characterized by reduced metabolic activity.

Dummy Nest: A nest that is not used for egg-laying but for mate selection.

Ectoparasite: A parasite that lives on the outside of an animal.

Ectotherm: An animal whose body temperature is largely dependent on the temperature of its external environment.

Endoparasite: A parasite that lives inside an animal.

Endotherm: An animal that is metabolically able to maintain a constant body temperature regardless of the temperature of its external environment.

Facial Disks: Special facial rings comprising densely packed feathers that direct sounds towards the ear openings.

Facultative Brood Parasite: An animal that provides care for its own brood but occasionally also exploits another animal's parental care for the rearing of additional young.

Fledgling: A young bird that has fledged (grown feathers and left the nest but is still dependent on parents for food).

Fovea: Retinal pits packed with sensory cells for more acute vision.

Freeze-tolerance: The ability to withstand and survive the formation of ice in the intercellular space.

Gizzard: The muscular stomach compartment of birds important in the physical breakdown of tough diet components, such as seeds.

Gloger's Rule: A general rule that paler animals are found in colder climates.

Glycerol: An alcohol widely used by animals as an antifreeze.

Guard Hair: The long outer hair on a mammal.

Herbivore: An animal that feeds primarily on plants.

Hibernaculum (pl. hibernacula): The site in which an animal hibernates.

Hibernation: The act of passing the winter in a dormant state. The term is often applied only to mammals.

Intermediate Host: A host in which the parasite does not reproduce.

Jacobson's Organ: A mass of sensory cells in the roof of the mouth important for detecting airborne scents. Also called the vomeronasal organ.

Johnston's Organ: An organ sensitive to the antennal spread of certain insects.

Lactation: Secretion of milk by the mammary glands.

Lateral Line: A series of sensory organs on the sides of fish sensitive to pressure changes in the water.

Marsupium: The pouch of a marsupial in which the altricial young nurse and develop.

Masseters: Muscles that power the crushing motion of the cheek teeth.

Mating Plug: see *Copulatory Plug*.

Migration: A seasonal or periodic movement to new resources and/or climates. Characteristically involves great distances.

Mixed-function Oxidase: An enzyme important for detoxifying plant poisons.

Mullerian Mimicry: A defense in which several animals look similar and share some repulsive quality.

Natural Selection: The driving force behind evolution. Natural selection is the retention and exemplification of adaptive characteristics in animals (and plants) due to interactions with the environment and other organisms.

Nestling: The unfledged young of altricial birds.

Nucleating Site: The site where ice formation first begins.

Obligate Brood Parasite: An animal that has no other reproductive option apart from exploiting the parental care of another animal for the rearing of its young.

Ovoviviparity: The retention of fully developed eggs inside the body until they hatch.

Parasite: An animal that derives its nutrition from the body of another living animal, usually without damaging the host.

Parasitoid: An insect that parasitizes another animal but in its feeding efforts kills the host.

Parental Care: The investment of time and energy into increasing the chances of the offspring's survival at the risk of decreasing the parent's survival chances and investment in other offspring.

Pellet: A ball of hair, bone, and other indigestible parts of prey regurgitated by certain predatory birds.

Pheromone: A chemical message often used to convey sexual information.

Photoperiod: The relative amounts of light and darkness in a night/day cycle.

Polyandry: One female having more than one male mate at one time.

Polygamy: Having more than one mate at one time.

Polygyny: One male having more than one female mate at one time.

Precocial: Born in an advanced and relatively independent state of development.

Primary Consumer: An animal that eats plants.

Radula: Unique to slugs and snails, a rasping mouthpart used to eat plant material.

Rods: Retinal sensory cells responsive to low light levels.

Rumen: The first stomach compartment of certain herbivores that contains microbes for cellulose digestion.

Ruminant: An animal that possesses a rumen.

Satellite Male: A non-territorial male that exploits the breeding opportunities of territorial males.

Secondary Consumer: An animal that eats herbivorous animals.

Sexual Reproduction: Reproduction involving the union of two gametes generally contributed by different parents.

Sexual Selection: The selective force responsible for the proliferation of physical or behavioral traits that confer no benefit apart from reproductive success. Generally powered by female choice or aggression between males.

Spermatophore: A package of sperm.

Startle Pattern: A bold pattern, often resembling large eyes and initially concealed, that startles the predator when displayed. It may also serve to deflect the predator's attack to a non-vital body part. Also known as a distraction pattern.

Stridulation: The production of communicatory sound by rubbing body parts together.

Supercooling: Water remaining in a liquid state below the freezing point.

Tapetum Lucidum: A reflective layer behind the retina in nocturnal animals.

Temporalis: Muscles that power the bite of an animal.

Tymbal: The sound-producing organ of a Cicada.

Underfur: The thick, soft hair underlying the long outer guard hair.

Vibrissae: Stiff tactile or sensory hairs.

Vomeronasal Organ: *see Jacobson's Organ.*

ADDITIONAL READING

Scientific journal articles and books dealing with some aspect of animal natural history number in the thousands. The following is a short list of recommended reading. I hope these references will open the door to at least a small part of the incredible wealth of information that exists.

Alerstam, T. *Bird Migration.* New York, NY: Cambridge University Press, 1990.

Andersson, M. *Sexual Selection.* Princeton, NJ: Princeton University Press, 1994.

Bauchot, R., ed. *Snakes: A Natural History.* New York, NY: Sterling Publishing Co. Inc., 1994.

Berthold, P. *Bird Migration: A General Survey.* New York, NY: Oxford University Press, 1993.

Clutton-Brock, T. H. *The Evolution of Parental Care.* Princeton, NJ: Princeton University Press, 1991.

Ernst, C. H., J. E. Lovich, and R. W. Barbour. *Turtles of the United States and Canada.* Washington, DC: Smithsonian Institution, 1994.

Gill, F. B. *Ornithology.* 2nd ed. New York, NY: W. H. Freeman and Company, 1994.

Halfpenny, J.C. and R.D. Ozanne. *Winter: An Ecological Handbook.* Boulder, CO: Johnson Pub. Co., 1989.

Halliday, T. *Sexual Strategy.* Chicago, IL: University of Chicago Press, 1980.

Harborne, J. B. *Introduction to Ecological Biochemistry.* 3rd ed. San Diego, CA: Academic Press, 1988.

Howe, H. F. and L. C. Westley. *Ecological Relationships of Plants and Animals.* New York, NY: Oxford University Press, 1988.

Krebs, J. R. and N. B. Davies. *An Introduction to Behavioural Ecology.* 3rd ed. New York, NY: Blackwell Scientific Publications, 1993.

Leather, S. R., K. F. A. Walters, and J. S. Bale. *The Ecology of Insect Overwintering.* Cambridge, MA: Cambridge University Press, 1993.

Lyman, C. P., J. S. Willis, A. Malan, and L. C. Wang. *Hibernation and Torpor in Mammals and Birds.* San Diego, CA: Academic Press, 1982.

Marchand, P. J. *Life in the Cold.* Hanover, NH: University Press of New England, 1987.

Macdonald, D., ed. *The Encyclopedia of Mammals.* New York, NY: Facts on File, 1984.

Owen, D. *Camouflage and Mimicry.* Chicago, IL: University of Chicago Press, 1980.

Owen, J. *Feeding Strategy.* Chicago, IL: University of Chicago Press, 1980.

Terres, J. K., ed. *The Encyclopedia of North American Birds.* New York, NY: Alfred A. Knopf, 1980.

Tyning, T. F. A *Guide to Amphibians and Reptiles.* Boston, MA: Little, Brown & and Co. Ltd., 1990.

Thorp, J. H. and A. P. Covich, eds. *Ecology and Classification of North American Freshwater Invertebrates.* San Diego, CA: Academic Press, 1991.

Willson, M.F. *Vertebrate Natural History.* Philadelphia, PA: CBS College Publishing, 1984.

Zug, G. R. *Herpetology.* San Diego, CA: Academic Press, 1993.

ABOUT THE PHOTOGRAPHS

SEVERAL INGREDIENTS ARE KEY TO ACHIEVing an acceptable wildlife photo: quality camera equipment, a sturdy tripod, superb film, and loads of patience. But equally important is a strong working knowledge of the subject matter. Knowing the behavior and habits of an animal eliminates much (but not all) of the frustration encountered by those who depend solely on luck.

All of my camera equipment is Canon. I use F1 bodies, which are durable, dependable workhorses in all weather conditions. The enormous range of animal species photographed in this book necessitated the use of a large variety of lenses. Insects and other invertebrates were photographed primarily with a 200mm macro lens, my all-time favorite Canon lens. This lens will not disappoint! The smallest subject in the book, a tenth of an inch long (2mm) larval Black Fly, was photographed with the 200mm macro lens mounted on a Canon autobellows. The fly larva, owl pellets, and Goldenrod Gall Fly maggot were all photographed under indoor lighting conditions. But with only a couple of exceptions, all other photographs were taken under natural light. I used either a Canon 500mm f4.5 or a 300mm f4 lens for most of the bird and mammal photographs.

The photographs were taken almost exclusively with two kinds of film, including Kodachrome 25 ASA, my film of preference. Its incredible sharpness and color rendition make it the finest film ever made, in my opinion. For years I refused to use any film faster than Kodachrome 64—too much was lost in color or sharpness. But now my thinking has radically changed. If light conditions are poor or if the subject moves around a lot, I now use Kodak Lumière X 100 ASA film. This product's sharpness and color saturation continually amazes me.

My preference for 25 ASA film meant that slow shutter speeds—1/30th of a second and slower—were often unavoidable. A Manfrotto 055 or a Gitzo tripod, therefore, was used for almost every shot.

For the most part, I avoid working out of a blind because I feel confined and somewhat isolated from the environment. But in situations where it is crucial that the animals not be disturbed—as in the case of the denning Red Foxes and nesting Great Blue Herons—a Gusti blind was handy.

Beyond the usual camera equipment and paraphernalia, the most important accessory for any serious nature photographer is access to a good library. Those who complain about the difficulty in seeing, let alone photographing, a wild animal usually know little about its habits. To obtain a reasonable photograph of a particular species, it only makes sense that one should know how to go about finding it. A knowledge of the animal's life history is essential to achieving a successful wildlife photograph.

As photographic subjects, animals can be frustratingly difficult to locate. They move almost continuously, and most have little tolerance for the presence of humans. And when they are encountered, they are often in situations that afford little, if any, photographic opportunity. I suppose that is why a good number of nature photographers use "wildlife models" or tame animals to get the photographs they want.

For me, though, the challenge lies in finding and recording on film an animal in its natural environment. This is what makes nature photography such an enjoyable pursuit. And always, without exception, the animal being photographed is far more important than the photograph. I would much rather (and often do) just watch an animal perform its ritual and lose a photographic opportunity than disturb it or cause it any stress.

As nature enthusiasts, naturalists, or photographers, we are truly privileged to have our lives enriched by such an incredible wealth of animal life. But it is highly improper for us to consider wild things merely as objects for our pleasure or profit. We all have an inherent responsibility to do our utmost to respect and preserve these irreplaceable living marvels.

INDEX